"A visual immensity in black and white that renders the stoic grandeur of half a century of everyday Baltimore. Capacious and gifted as a photographer and meticulous as a print-maker, Mayden harvests the soulful, complex interiors of his subjects and refines the gray shades that bind human experience."

Lawrence P. Jackson, author of *Chester B. Himes: A Biography*

"In these rich and penetrating photographs, John Clark Mayden captures the beauty and complexity of Baltimore. These works are both intimate and immense; they reveal individual stories and broader histories in ways that obliterate tired media narratives about the city. This is a remarkable collection and should not be missed."

Kevin Tervala, Associate Curator of African Art, The Baltimore Museum of Art

"John Clark Mayden's moving photographs capture a slice of urban life over a forty-year period in a complex city represented by symbols of both joy and pain."

Kurt L. Schmoke, President, University of Baltimore

"John Clark Mayden frames the complexity of black life in Baltimore by illuminating a sense of belonging that he is tied to culturally and artistically. The moments in this book are both quiet and lively; we see the exchange from a windowsill, stoops, and benches. The result is a fascinating series of portraits that shows us how he approaches life in his home city."

Deborah Willis, Tisch School of the Arts, New York University

"John Clark Mayden photographically captures, in portraits and street scenes, a different urban reality, one that is rarely seen or acknowledged but is in need of serious consideration."

Robert M. Bell, former Chief Judge of the Maryland Court of Appeals

"From where I stand, there are two ways to visit Baltimore: hop off the train, bus, plane, or car and conduct your own damn walking tour, or look at John Clark Mayden's book, *Baltimore Lives*. That he has been at this for more than forty years—making significant, penetrating, and honest photographs of his hometown—comes as no surprise. Mayden is curious, driven, and accomplished. The pictures strike a sense of sincerity and clear vision right into the mind and heart of the viewer. People have taken pictures of their neighborhoods since photography was invented in 1839. Mayden approaches this task as if he is the neighborhood."

Peter MacGill, President, Pace/MacGill Gallery

BALTIMORE LIVES

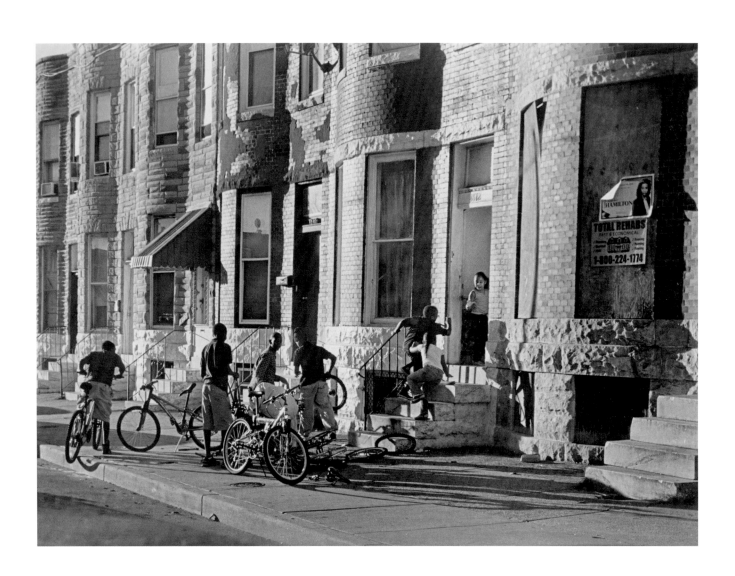

John Clark Mayden

BALTIMORE LIVES

The Portraits of John Clark Mayden

Johns Hopkins University Press
Baltimore

This book was brought to publication with the generous assistance of the Office of the Provost and the Sheridan Libraries, Johns Hopkins University.

© 2019 Johns Hopkins University Press
Photographs © 2019 John Clark Mayden / Artists' Rights Society (ARS), New York
All rights reserved. Published 2019
Printed in Canada on acid-free paper
9 8 7 6 5 4 3 2 1

Johns Hopkins University Press
2715 North Charles Street
Baltimore, Maryland 21218-4363
www.press.jhu.edu

Library of Congress Cataloging-in-Publication Data

Names: Mayden, John, 1951– Photographs. Selections. |
 Tabb, Winston, writer of foreword. | Johns Hopkins University Press, issuing body.
Title: Baltimore lives: the portraits of John Clark Mayden /
 [photography by] John Clark Mayden.
Description: Baltimore, Maryland : Johns Hopkins University Press, [2019] |
 Includes bibliographical references.
Identifiers: LCCN 2019002036| ISBN 9781421432847 (hardcover : alk. paper) |
 ISBN 1421432846 (hardcover : alk. paper)
Subjects: LCSH: Street photography—Maryland—Baltimore. | Portrait
 photography—Maryland—Baltimore. | Mayden, John, 1951–
Classification: LCC TR659.8 .P67 2019 | DDC 779.09752/71—dc23
LC record available at https://lccn.loc.gov/2019002036

A catalog record for this book is available from the British Library.

Frontispiece: The Gathering, West Lafayette Avenue, 2012. Photo by John Clark Mayden

Special discounts are available for bulk purchases of this book. For more information, please contact Special Sales at 410-516-6936 or specialsales@press.jhu.edu.

Johns Hopkins University Press uses environmentally friendly book materials, including recycled text paper that is composed of at least 30 percent post-consumer waste, whenever possible.

CONTENTS

Foreword

Winston Tabb

Sheridan Dean of University Libraries & Museums
Johns Hopkins University

Children staring somberly through the worn window screens of a rowhouse. People in the snow waiting for the bus. A fist bump between two men in front of a barbershop. John Clark Mayden has lovingly chronicled the everyday beauty and pain of Black life in Baltimore for more than forty years, capturing fleeting moments with his camera and documenting people and places that might otherwise be overlooked. When we were approached by Lawrence Jackson, Bloomberg Distinguished Professor of English and History at Johns Hopkins University, about bringing a collection of John's photographs to the Sheridan Libraries, we were immediately excited by the opportunity to preserve this vital and evocative visual record. We are honored to be the custodians of John Clark Mayden's collection and to have the responsibility of opening it up to the world—through this publication and the corresponding exhibition at the George Peabody Library.

The 101 photographs in this volume, especially when examined alongside essays by John's sister, Ruth, and the eminent artist and art historian Michael D. Harris, offer an intimate look at John Clark Mayden's Baltimore. As a Baltimore native, John has a lifelong, firsthand experience of a city that is frequently represented in the news and popular media as a place torn apart by violence, drugs, and crime. Yet his are not the famous and famously one-sided scenes of a broken city, although he does not shrink from tragedy, nor are they tributes to Baltimore's iconic landmarks and attractions, although these places may occasionally appear in his pictures. Instead, turning his lens on some of Charm City's neglected neighborhoods, John reveals the poetry of the commonplace, with its daily routines, hardships, joys, and quiet moments, often as they take place in public, and especially as they are experienced by the often marginalized and misrepresented Black citizens of Baltimore.

John seems to be a born street photographer, audaciously catching hold of the constant theater of the urban environment. But if you look closely, you will see that these pictures are also the product of tremendous craft and aesthetic care. John takes long walks through the city, absorbing the rhythms that guide his eye, and works long hours in the darkroom, exploring light and tonality to develop forms, textures, and shadows. This labor-intensive and old-fashioned process is fundamental to his remarkable, transformational enterprise, turning daily life into art—or, rather, as he might say, uncovering the art that is already there.

What is equally remarkable about John is his generosity in giving a significant selection of his life's work to the Sheridan Libraries. This gift will have a lasting impact for the libraries, for the university, and for the city that we call home. The collection allows students, photographers, historians, and art historians to see through John's eyes, and thus to trace in detail elements of the Black experience in late twentieth- and early twenty-first-century Baltimore. We anticipate with pleasure the many wonderful discoveries they will make in and through it, in response.

I thank John Clark Mayden now not only on behalf of today's researchers, viewers, and artists, but also on behalf of those who will benefit from his generosity for generations to come.

BALTIMORE LIVES

John Clark Mayden

Ruth W. Mayden

When my brother was very young, he rarely spoke. I remember how intently he watched as those around him went on with their activities and conversations. At that time, I wondered what he was thinking. Today, looking at some of the thousands of images he has created, I realize that it was more about what he saw in those moments rather than what he thought about what he was seeing.

In his teens, John became a vocal advocate for social justice. He rallied classmates, protested, demonstrated, and challenged. His activism was loud and unapologetic. As an adult, John continues to be an advocate by using photography as his voice. Still unapologetic, he makes it possible for the viewer to see, contemplate, and appreciate a wider world.

While attending Ohio Wesleyan, John chose to major in political science / government and fine arts. The first major made absolute sense to me given his interest in local and national elections and issues such as poverty, racial injustice, and the Vietnam War. His decision to make fine arts an equal area of study was a bit more of a mystery to me.

The four-and-a-half-year gap between our ages meant that I, as a graduate school student and then a professional, missed seeing his growing interest in studying how to visually present his political and social concerns to others. Fine arts, by its very name, suggested a more esoteric form of expression. Art for its own sake. I have come to appreciate John's skill at presenting the everyday—the ordinary—in ways that any viewer can appreciate is a gift.

As an untutored viewer, I create stories about the lives of the subjects of the photographs. For other viewers, there are different ways to enjoy the images. Each image evokes conversation during which different points of view can be expressed, about the social and political factors that affected the lives of the subjects or about the wisdom of the choices they are presumed to have made.

My brother conceived these photographs in curiosity and nurtured them in empathy and respect for the lives they represent and hope for the future we can change for them. I am honored to offer these few words in recognition of his artistry.

Ruth W. Mayden, John Clark Mayden's sister, is a graduate of Western High School and Morgan State University in Baltimore, Maryland, and Bryn Mawr College Graduate School of Social Work and Social Research in Bryn Mawr, Pennsylvania. She is a former dean of Bryn Mawr College Graduate School of Social Work and Social Research and a former program director for the Annie E. Casey Foundation.

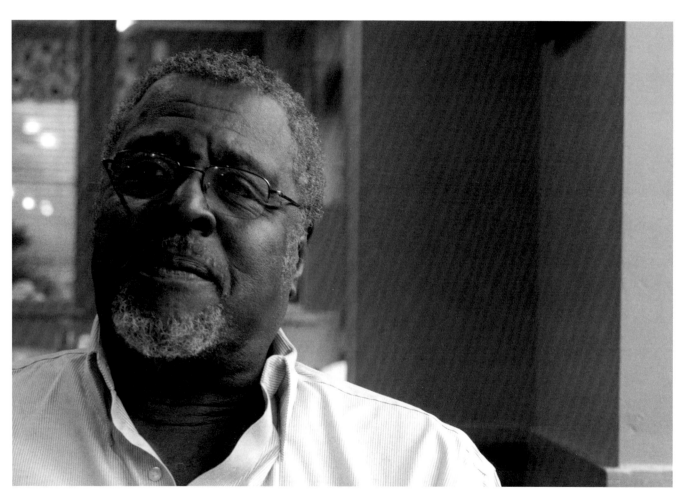

Photo by Michael D. Harris

Mayden Voyage
Baltimore through the Eyes of John Clark Mayden

Michael D. Harris

Oh, Baltimore
Ain't it hard just to live?
Oh, Baltimore
Ain't it hard just to live?
Just to live
> — From the song "Baltimore,"
> as sung by Nina Simone

Whatever it grants to vision and whatever its manner, a photograph is always invisible: it is not what we see.
> — Roland Barthes, *Camera Lucida:*
> *Reflections on Photography*

John Clark Mayden is a born and bred Baltimorean. But he does not live in the light of constant praise from his fellow citizens nor is he a prodigal child who, like Billie Holiday or Frederick Douglass, has received belated recognition after a notable career elsewhere. Independent and self-motivated, Mayden has walked the streets of the city for forty years or more, most often carrying a camera, and he can tell you of ghosts, histories, and memories of this spot and that one. His images "linger on the front steps and in the little backyards of rowhouses, in neighborhoods that are distinctive to our city and specific to Black life here."[1] But these pictures are far from nostalgic. They strip Baltimore of pretense and illusion and show you the city's veins.

Mayden is a street photographer, a genre that goes back to the beginning of photography, and his focus is on urban Baltimore, especially Black Baltimore. He says, "That's what I have known the most. I grew up in this city and I'll always love this city. I'm familiar with it." He has limited his subject matter to Baltimore's people, "ordinary people living their lives" because, at the end of the day, that is where he finds hope.[2]

The historian Robin Kelley suggests that Black photographers have frequently worked toward a larger purpose—and we can easily find John Clark Mayden within this tradition as Kelley describes it.

Michael D. Harris, MFA, PhD, is an associate professor of art history in the Department of African American Studies at Emory University.

Most of the men and women responsible for visually documenting black America were not simply obsessed with race. As modern visual poets, they were equally concerned with locating and reproducing the beauty and fragility of the race, the ironic humor of everyday life, the dream life of a people. Whether through portraiture or impromptu "street" shots, black photographers sought to capture something deeper than victimization, more complex than a heroic rebellion against the Man. And they found it: the interior life of Black America, the world either hidden from public view or forced into oblivion by the constant flood of stereotypes.[3]

How does the pursuit of this larger purpose suit the Black photographer? The French philosopher Roland Barthes suggested that photographs and other forms of expression can be seen as "texts" that, like works of literature, ask to be interpreted. A work of capital *L* Literature, or any work of art, is born when the text is seen and interpreted as something important that stands apart from its creator. But that birth is also the "death of the author." Paradoxically, the work of art that stands on its own erases "the very identity of the body writing."[4] It destroys its own author because it is "the destruction . . . of every point of origin."[5] This inverse relationship between the ripening text and its disappearing author is heartbreaking when both artwork and artist have been historically invisible—like the Black photographer revealing "the interior life of Black America."

Barthes reminds us that, for example, looking at Mayden's photographs, the viewer cannot see immediately the gender, culture, race, religion, or age of the photographer—only the photograph. The photograph is a record of an instant that occurred only once, but since it can be endlessly reproduced, it is also an infinity. Barthes argued that "the Photograph mechanically repeats what could never be repeated existentially."[6] What is repeated, and what is seen, is what is inside the photo—not the photograph itself as an object and not the one who framed it. However, with patience, the viewer can begin to excavate the marks of the photographer and, in effect, revive the author.

One way to recover the presence of the Black photographer is to appreciate the particular details he or she records—to see how these details are the residue of the photographer's individual vision and experience. In many old African cultures, including Egyptian, Central African BaKongo, and West African Yoruba, imagery often is based on stylization of the natural world, and the image signifies evidence or explication of the underlying, unseen world of relationships, principles, and ideas. This kind of cultural frame still informs African American ways of being in and seeing the world, and it has long affected the work of Black photographers and their approach to their subjects. The concrete is used to evoke abstract ideas or metaphorical relationships; this technique shows up in language idioms like "tighter than a rubber band around a fat man." Barthes's theories may give photography its due as an art form, but to really see the work of a Black photographer like Mayden, it seems profitable to filter those theories and incorporate them into African American cultural elements and practices. The idea that all art is autobiographical, in some ways, prevents us from

disconnecting the photographer from the photos while opening doors of insight into the process and vision of a photographer like John Clark Mayden.

The Photographer

Mayden is hard pressed to name people he looked up to while growing up in Baltimore, a fact consistent with his self-motivation, self-confidence, and internal drive. The same independence is evident regarding the influence of other photographers on the development of his photographic style and approach, though he does appreciate the work of some, such as Roy DeCarava (1919–2009), Anthony Barboza (1944–), and Alfred Stieglitz (1864–1946).

Mayden was an outstanding athlete in his younger years, and those talents gave him an advantage while taking photographs on the streets of his native city. His track prowess came in handy from time to time when he faced dicey situations and needed to make a hasty departure. His size and ability to fight, learned through judo, as well as his experience playing football, did not hurt during these encounters. Social intelligence, or "street smarts," helped him know when to choose fight or flight. Now, out on the city streets, he senses increased levels of hostility. He notes, "I usually now avoid some of the guys that I see who would be a real problem. As I've gotten older . . . you are beyond being able to outrun anybody anymore!"[7]

Physical agility and Baltimore wisdom gave him access to the street, but Mayden was never just one thing. As a student at Northwestern High School, then Ohio Wesleyan University, and finally law school

at the University of Baltimore, he also invested in his great intelligence. He worked in television for a time and was an attorney for many years.[8] But he always kept a camera nearby. His work appeared in the second and third volumes of *The Black Photographers Annual*, in newspapers, in exhibitions at the Baltimore Museum of Art, the University of Pennsylvania, the Walters Art Museum, and the Corcoran Art Gallery, among others, and in the documentary film *Through a Lens Darkly: Black Photographers and the Emergence of a People*.

The Process

Mayden likes the craftsmanship of working with film and printing on silver halide paper. He often uses a medium format Hasselblad camera on the street—an amazingly expensive brand of camera, which may be why he occasionally needs a quick exit. He primarily uses Tri-X black-and-white film and shoots at different ISO speeds to control shadow detail. Then, he uses chemistry to achieve the particular outcome he wants.

> I think the tonal qualities, being able to work in middle values . . . you can get more out of it. You can make the tones sing when you do that. You also can involve heat with the chemistry. And you can really bring out a strength that I don't think you necessarily get in the same way [with digital]. When you use digital, you've got sensors that are helping; you aren't thinking your way through everything—where it is you moving it. It's analyzing for you when you use the digital approach, I think. And I have to be in charge when I'm in my darkroom.[9]

Mayden keeps the darkroom in mind when he shoots. He says:

> When I shoot, I am thinking, "How am I going to do this when I'm on the next step?" So, the choice: the choice of chemistry as to what I'm going to develop it in. Am I going to make the negative real thick, because of how I want the final print to be? are thoughts that cross my mind.[10]

He was an artist-in-residence at Light Work at Syracuse University and there had access to digital studios. However, when the man running the digital lab offered to make a high-quality digital print of his work, Mayden put the prints side by side and remained convinced that the silver was superior. So, he continues to develop and print all of his work; he manages each step of the process to create the specific image and effects he envisioned while shooting.

The Photo

Barthes described what it's like to perceive the unique moment captured by the photograph and the phenomenon of peering across time back to that no-longer-existing instant, place, and circumstance. "One day, quite some time ago, I happened on a photograph of Napoleon's youngest brother, Jerome, taken in 1852. And I realized then, with an amazement I have not been able to lessen since: 'I am looking at eyes that looked at the Emperor.'"[11]

Photographs, taken by particular photographers at specific moments, can offer insight into the human condition at certain times and places, and, if we read them intentionally, can also give the viewer a sense of the consciousness behind the camera. The viewer can, in a sense, look into a face and experience an interval from the past that might have existed before the viewer was born and will never occur again. Barthes proposed that we don't see the photograph, but what is in it. As viewers, as we are drawn into the world, apprehended and frozen by the camera, we oscillate between this kind of seeing and the feeling that, somehow, we are being guided by the photographer's eye— the feeling that the photograph is the materialization of that authorial/artistic consciousness.

John Clark Mayden's work is more in the tradition of the great French photographer Henri Cartier-Bresson, famous for the "captured moment," than that of Ansel Adams, known for his clear, rich, black-and-white landscapes, or even that of Roy DeCarava, the distinguished portrait photographer of Black jazz artists. In Mayden's photographs, as in Cartier-Bresson's, we meet people who are not expecting us. We can see the details of their lives as African Americans in Baltimore; their emotions, changing modes of dress, gestures, and faces that sometimes reveal more than they conceal. We can go places that we might never visit otherwise—places that don't exist any longer or that an outsider or tourist might not ever know existed. Mayden takes us to places that might not be safe for us, and are sometimes unsafe for him. But, in all these places, regardless of the camera's presence, people go on waiting for the bus, catching a breeze on their front steps, slogging through the snow to work and school, and, every so often, returning the photographer's gaze with a grin, a glance, a frown, or a lost-in-thought stare.

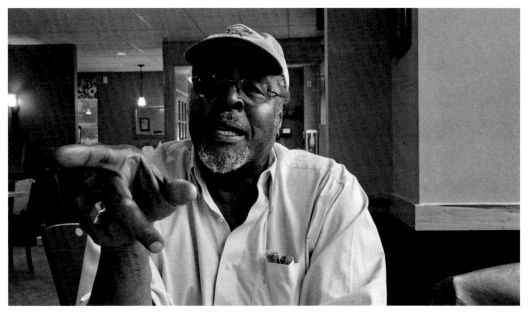

Photo by Michael D. Harris

There is nothing haphazard about Mayden's journey. His images are framed and composed with a knowledge of light and angle, polished with a quiet manipulation of levels of contrast and middle tones, and printed with a sense of whether to use a warm or a cool paper. As finished photographs, they reveal with startling specificity moments in the everyday lives of ordinary people, without the historical fascination evoked by a figure like Abraham Lincoln or Frederick Douglass. Mayden privileges his experiences, his lens, what he sees and what he knows. Billie Holiday, for example, is a star in Baltimore's past—but not a person he knew.

> I am aware that she performed at the Royal Theater; I have some pictures of that. You appreciate the impact that people like Billie Holiday had on others. . . . She was mentioned [in his life experience]. My mother

liked her. [Sings a bit of "Ain't Nobody's Business If I Do."][12]

What matters to Mayden is Billie Holiday as she was wrapped up in the old Royal Theater and memories of his mother, not Billie Holiday the doyenne of the Blues. His emphasis is on people who are largely invisible in the sense of Ralph Ellison's *The Invisible Man* and who are made viscerally visible in his work. As Kelley writes, these voiceless people lived and live; in Mayden's photos, we have creative proof that their everyday lives, like all of our everyday lives, are possessed of an intensity and depth that is "deeper than victimization."[13]

Mayden's work, a small sliver of which is revealed here, offers a tour of a certain segment of Black Baltimore, given by an "author" who (according to Barthes) is erased in the process of creating something new—photographic work that, illuminating

at last what has been unseen, exists independently of the photographer. But if we read it carefully, we find that his work actually re-presents what it represents—that the artist is reflected back into the photograph in his act of honoring his subjects with recognition. And so the subject of Mayden's work includes not just the people we see and not just the context of Baltimore that frames them, but the photographer himself.

The rich history of Baltimore's African American inhabitants continues to be burdened by racism and its structures. However, these are people who, like all people, are navigating the opportunities and problems that are in front of them, despite this dark past. Sometimes there is indignity and defeat; sometimes beauty and triumph. John Clark

Mayden is complicit in this Baltimore and the everyday life of its people. With his intelligence, creative energy, self-assuredness, humor, and camera, he gives us insight into his and their complicated being.

> There ain't nothing I can do
> Or nothing I can say
> That folks don't criticize me
> But I'm going to do
> Just as I want to anyway
> And don't care just what people say
> If I should take a notion
> To jump into the ocean
> Ain't nobody's business if I do
>
> If I should take a notion
> To jump into the ocean
> Ain't nobody's business if I do[14]

Notes

Nina Simone's reggae version of "Baltimore," lyrics by Randy Newman, was recorded in 1978.

1. Gabrielle Dean, email to Michael Harris, September 10, 2018.
2. John Clark Mayden, interview by Michael Harris, November 9, 2018, Owings Mills, MD.
3. Robin D. G. Kelley, foreword to *Reflections in Black: A History of Black Photographers 1840 to the Present*, by Deborah Willis (New York: W. W. Norton, 2000), x.
4. Roland Barthes, "The Death of the Author," in *Image Music Text*, sel. and trans. Stephen Heath (London: Fontana Press, 1977), 142.
5. Barthes, "Death," 142.
6. Roland Barthes, *Camera Lucida: Reflections on Photography*, trans. Richard Howard (New York: Hill and Wang, 1982), 4.
7. John Clark Mayden, interview by Michael Harris, October 13, 2018, Owings Mills, MD.
8. Mayden has lived a life committed to lifting his community through large and small efforts, such as helping to reopen the second oldest YMCA in the country, dedicating forty years to the Eubie Blake Cultural Center, ten as its chairman, and working for twenty-two years as a litigator for Baltimore City. He says, "Compassion has always been a key element of my life and work." John Clark Mayden, email to Michael Harris, December 7, 2018.
9. Mayden, interview, October 13, 2018.
10. Mayden, interview, October 13, 2018.
11. Barthes, *Camera Lucida*, 3.
12. Mayden, interview, November 9, 2018.
13. Kelley, foreword, *Reflections in Black*, x.
14. "Ain't Nobody's Business If I Do" (1922), lyrics by Everett Robbins and Porter Grainger, was first recorded by Billie Holiday in 1949 and first published on her 1956 compilation album *The Lady Sings*.

PORTRAITS

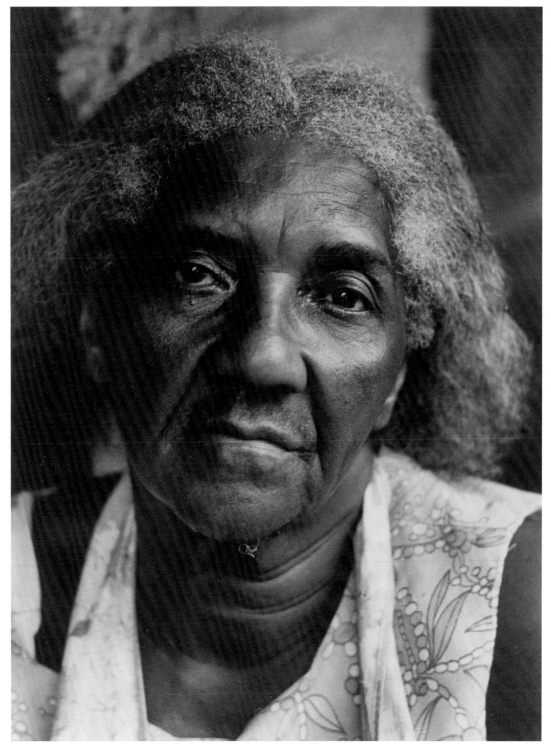

Contemplation West of Greenmount Avenue, 1972

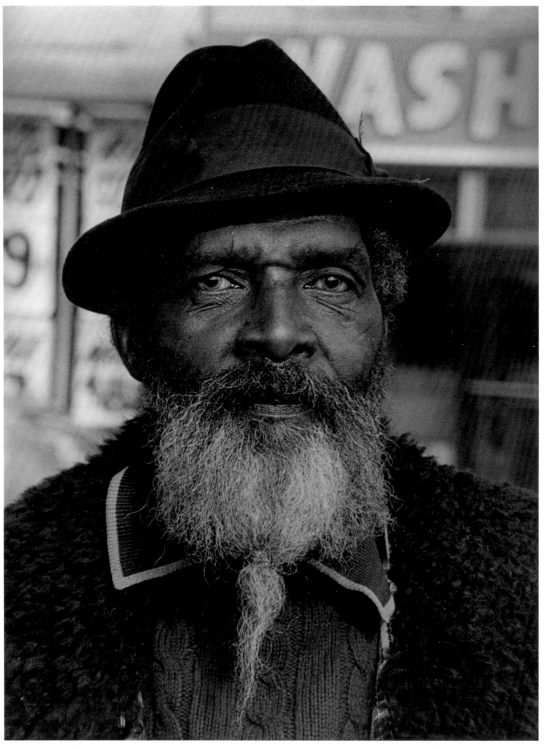

Urban Squire Pennsylvania Avenue near Robert Street, 1983

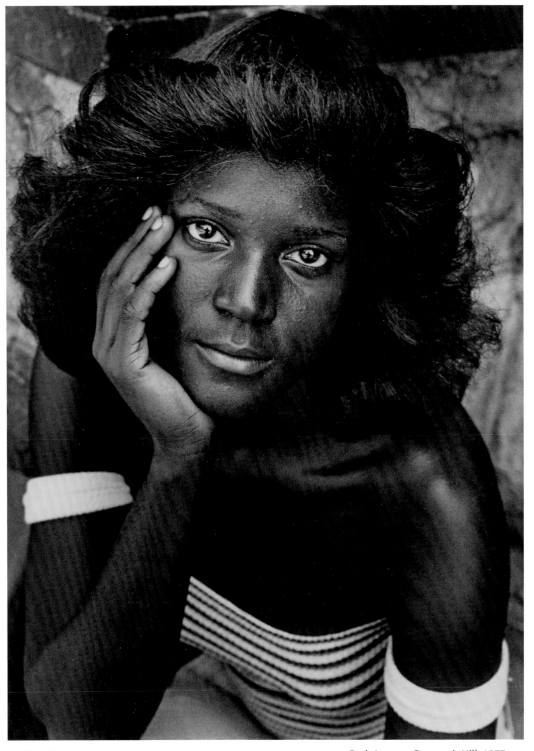

Beauty Park Avenue, Reservoir Hill, 1977

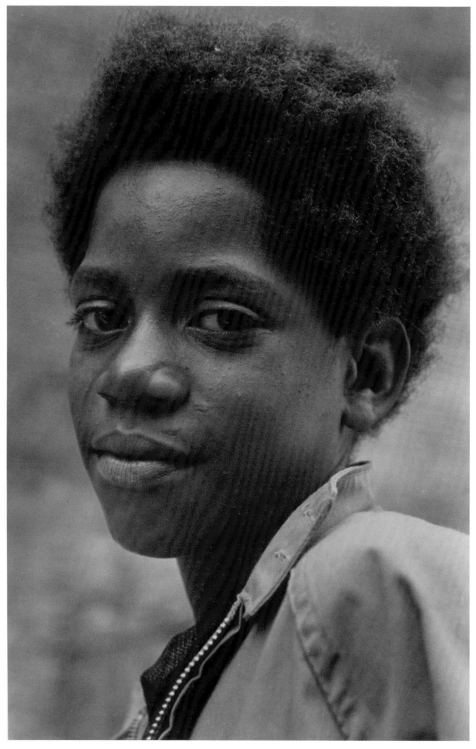

Untitled West Baltimore, 1972

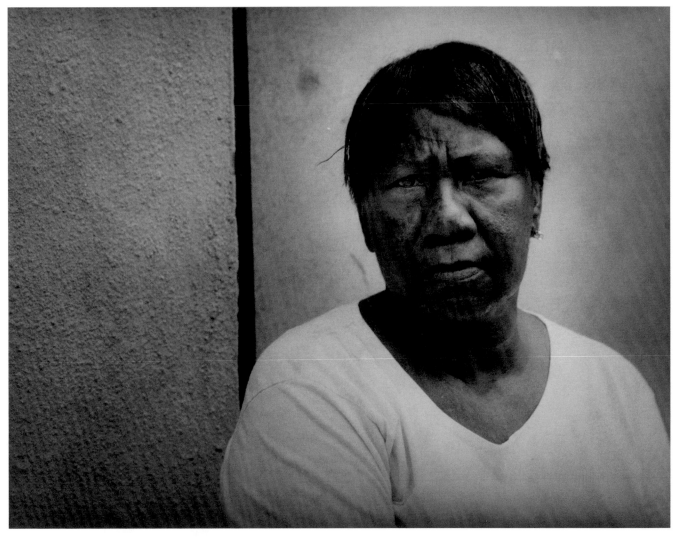

Untitled South Green Street, 2005

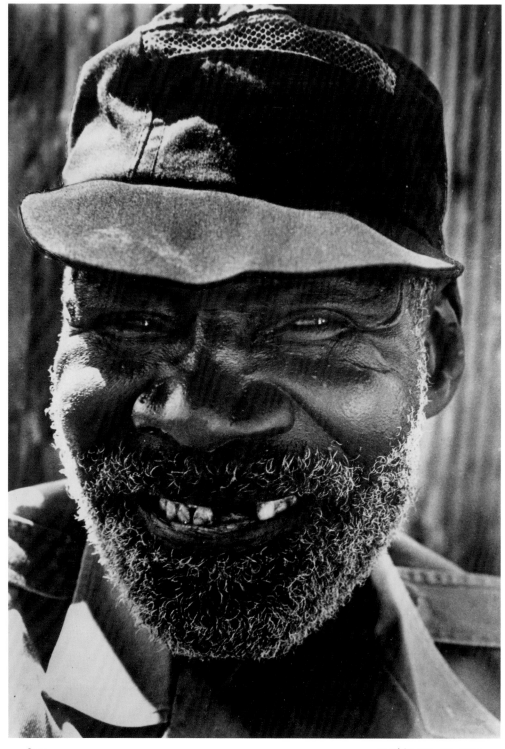

Sam Washington, DC, 1973

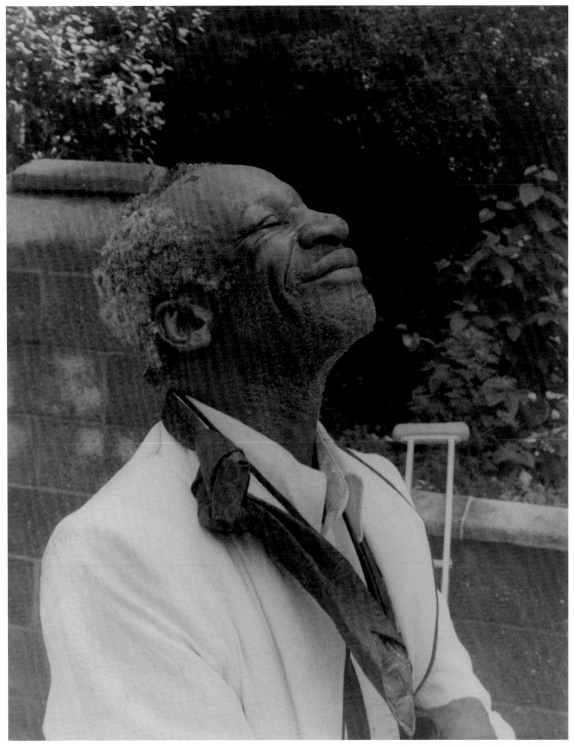

George E. Johnson

Reservoir Hill Block Party, 1978

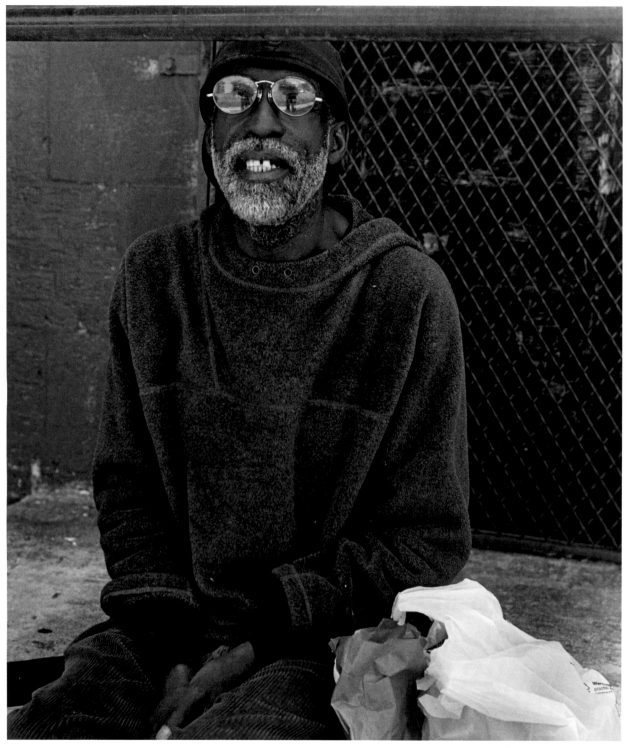

Friends

Laurens Street at Pennsylvania Avenue, 2007

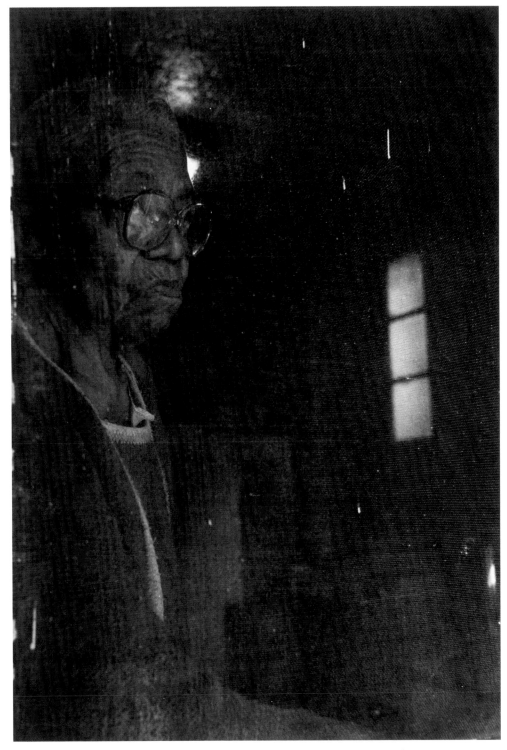

Granny at the Back Door

Ruskin Avenue, 1976

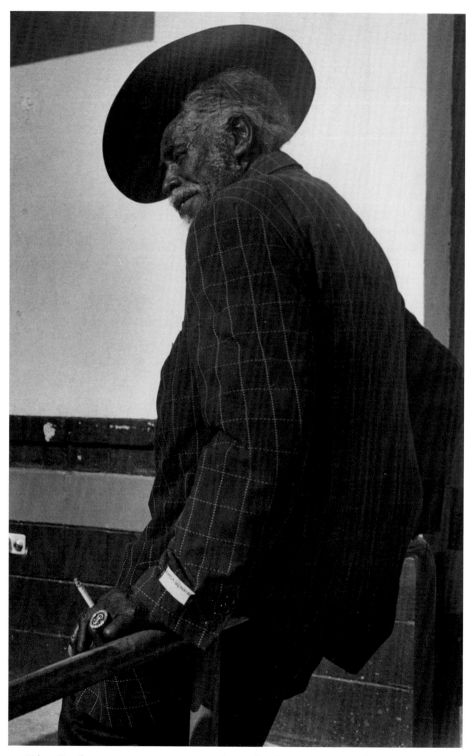

Urban Gentleman Pennsylvania Avenue near Robert Street, 2005

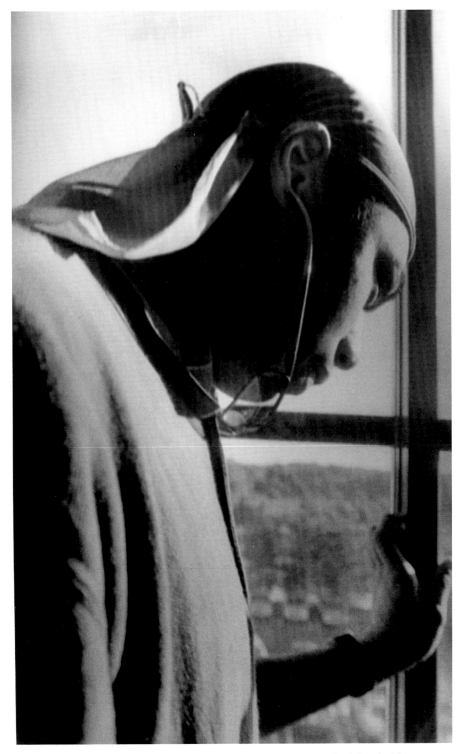

Adam Fort Lauderdale, Florida, 2004

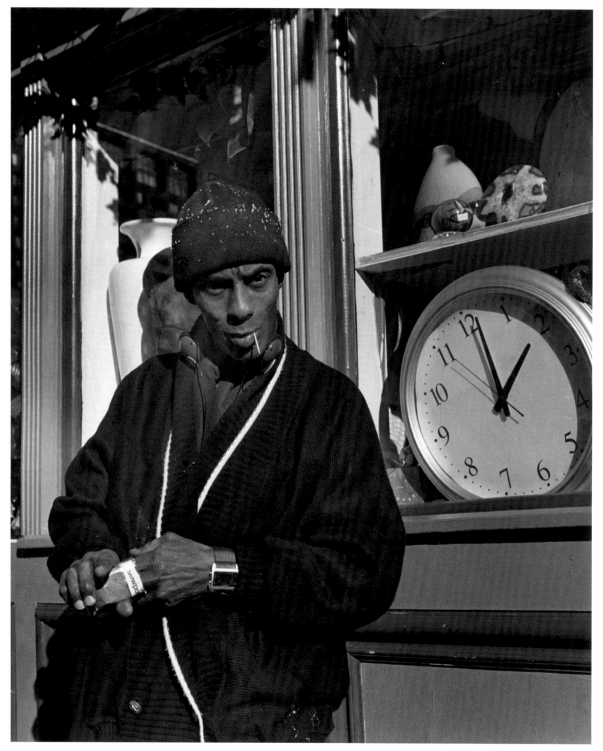

What's Up

South Charles Street Bus Stop, 2007

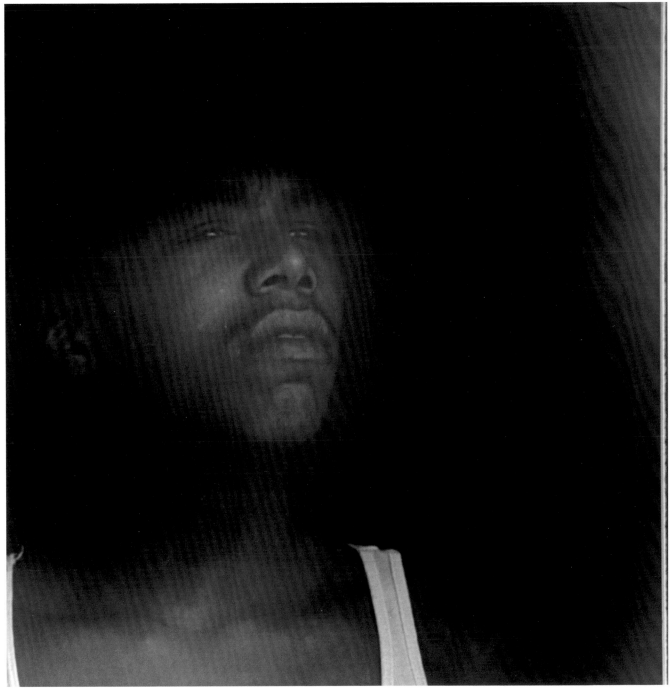

Adam

Fort Lauderdale, Florida, 2005

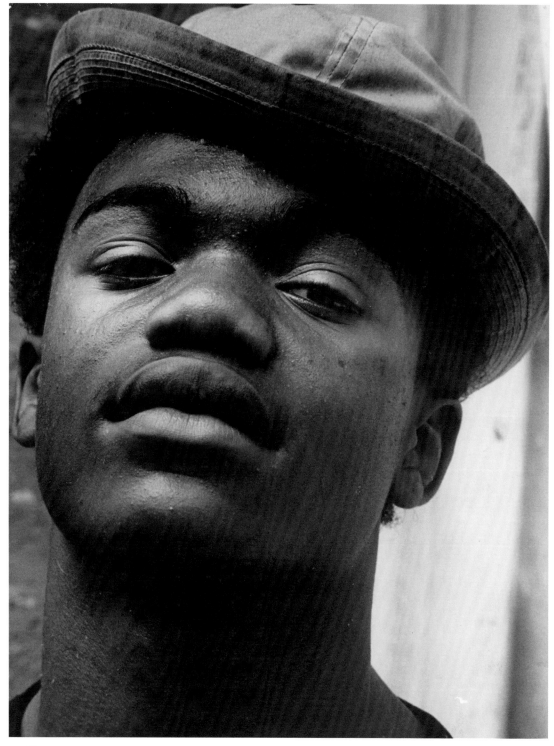

Slugger

West Baltimore, 1972

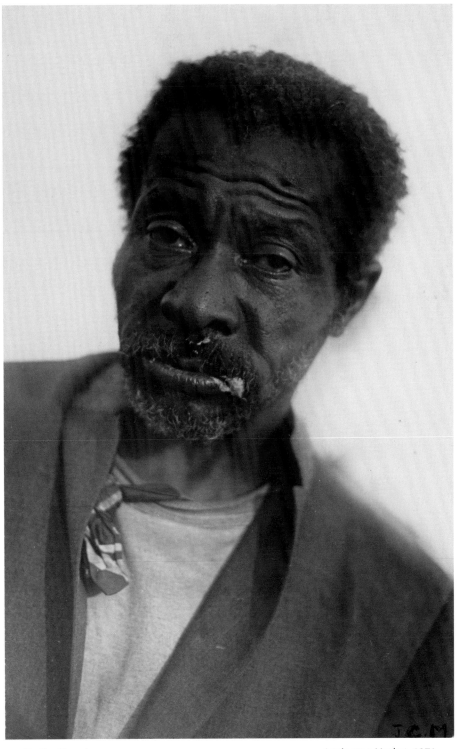

On the Street Lexington Market, 1971

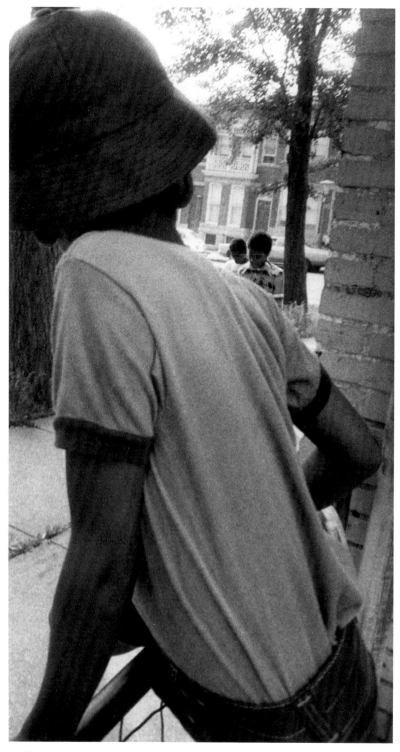

Kenny

Ruskin Avenue, 1972

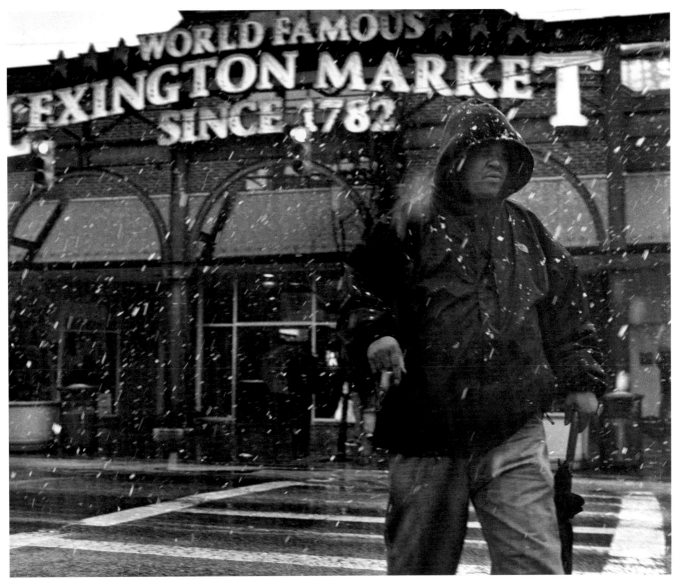

Since 1782

Lexington Market, 2009

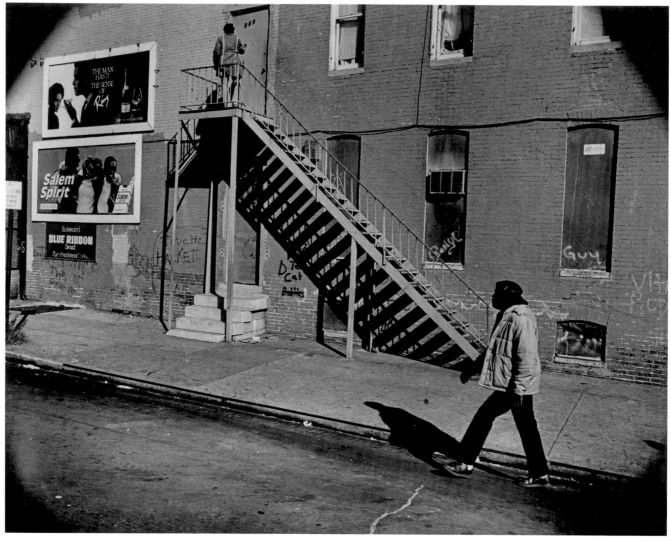

Northward Bound

Division Street, 1984

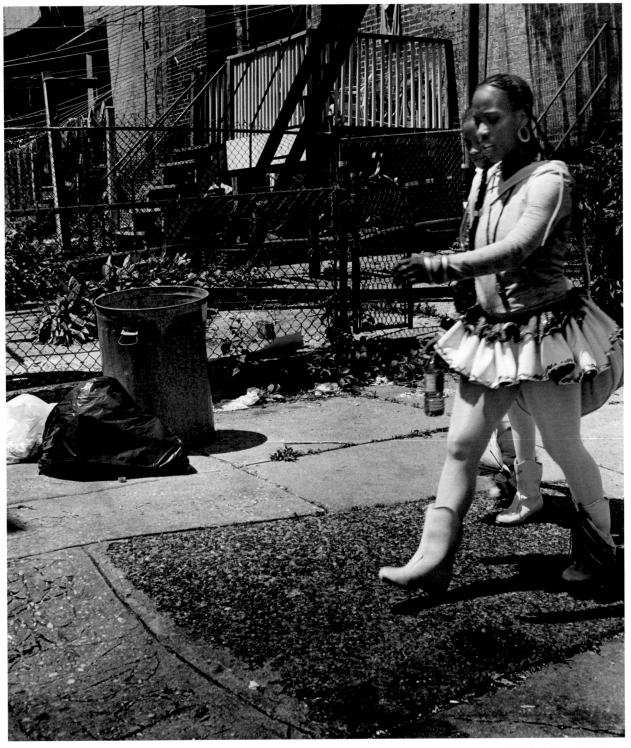

After the Parade

Division Street, 2007

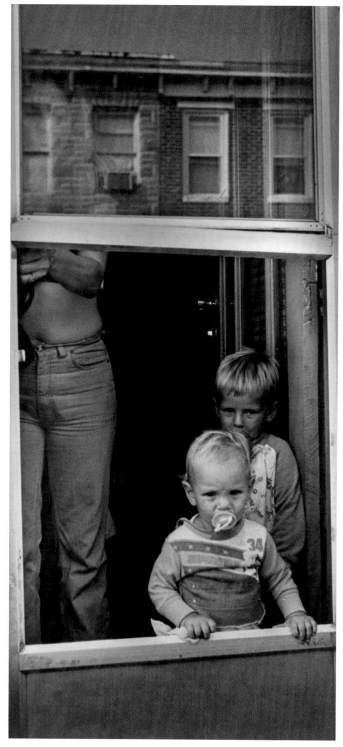

Fruit of Labor South Monroe Street, 1984

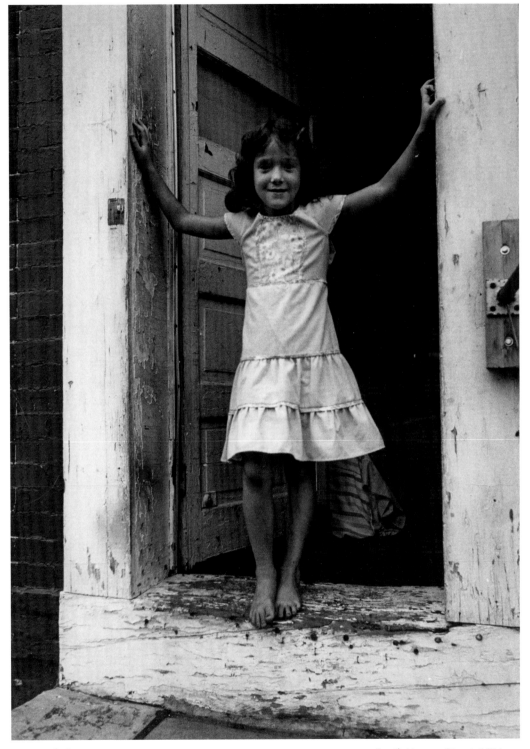

Untitled South Monroe Street, 1984

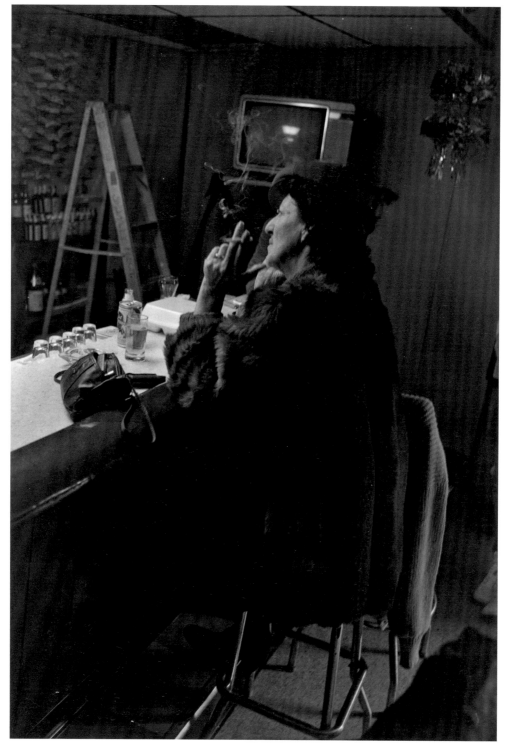

Happy Hour

Southwest Baltimore, 1984

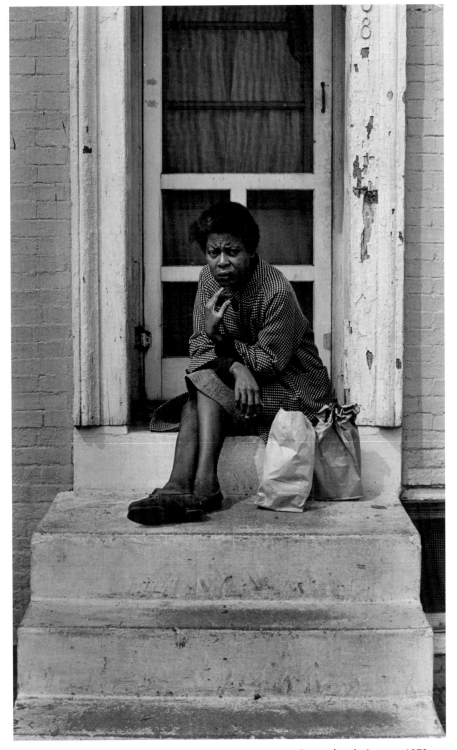

Mama Pennsylvania Avenue, 1972

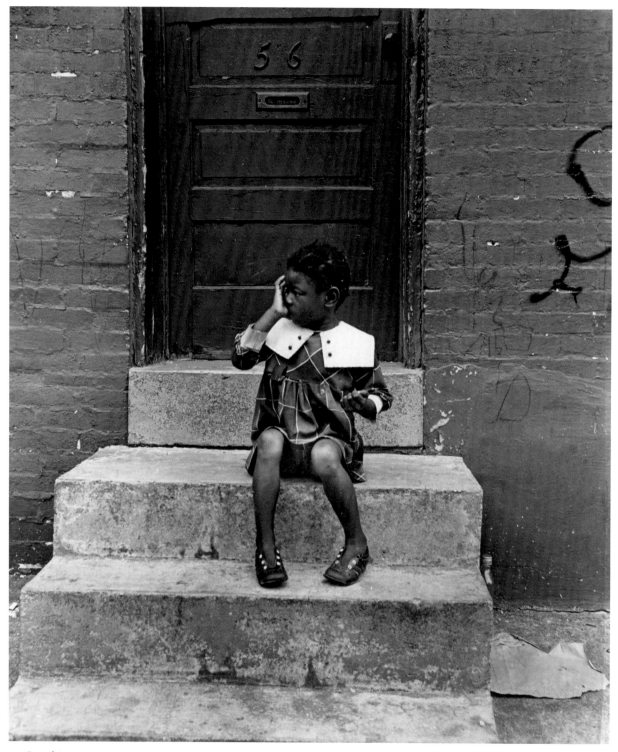

Daughter

Pennsylvania Avenue, 1972

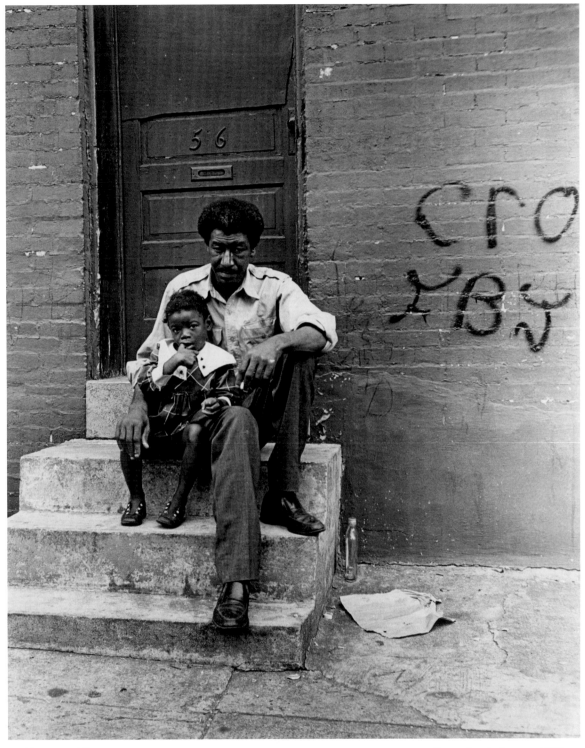

Future and Now

Pennsylvania Avenue, 1972

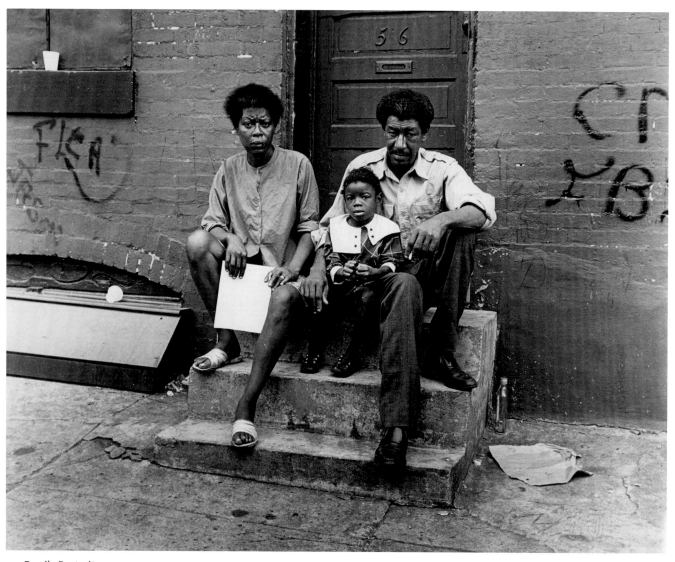

Family Portrait

Pennsylvania Avenue, 1972

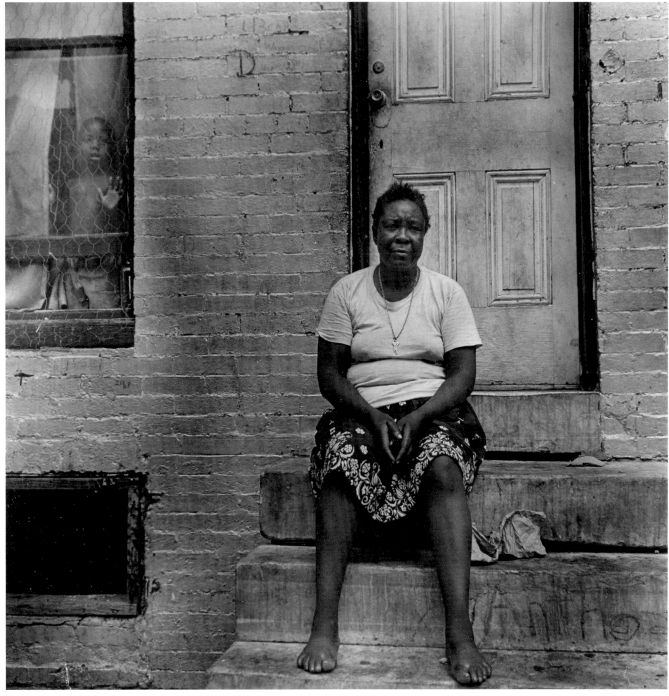

Granny and Grandson

East Baltimore, 1972

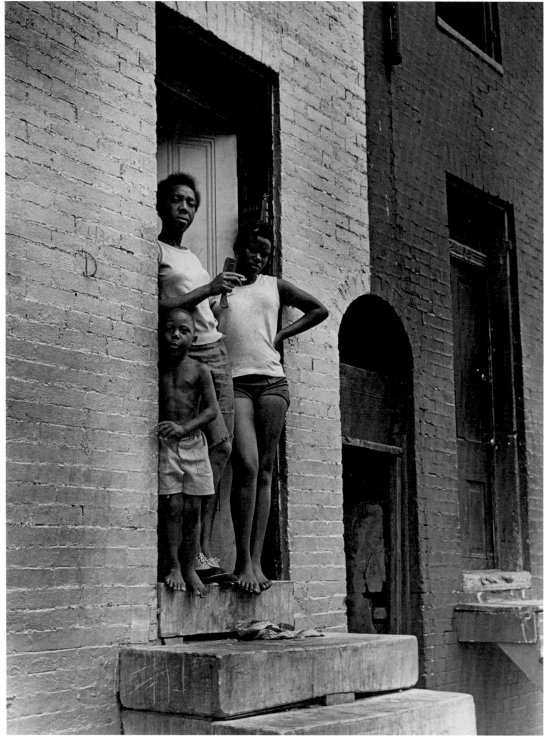

Family East Baltimore, 1972

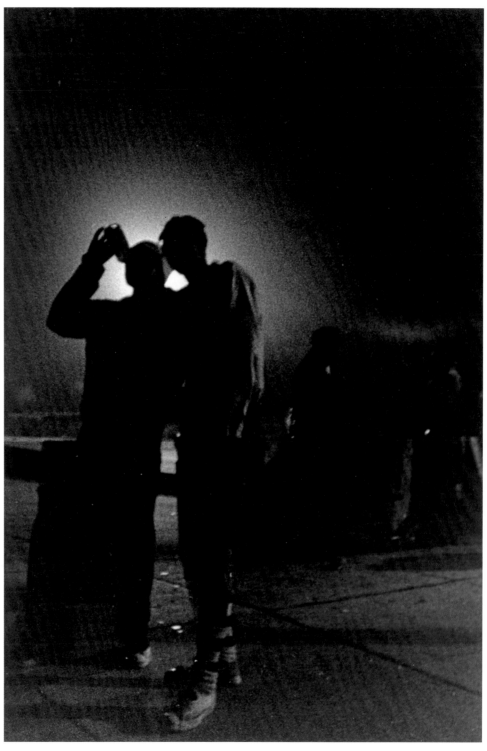

Quenching Thirst Pennsylvania and Lafayette Avenues, 1975

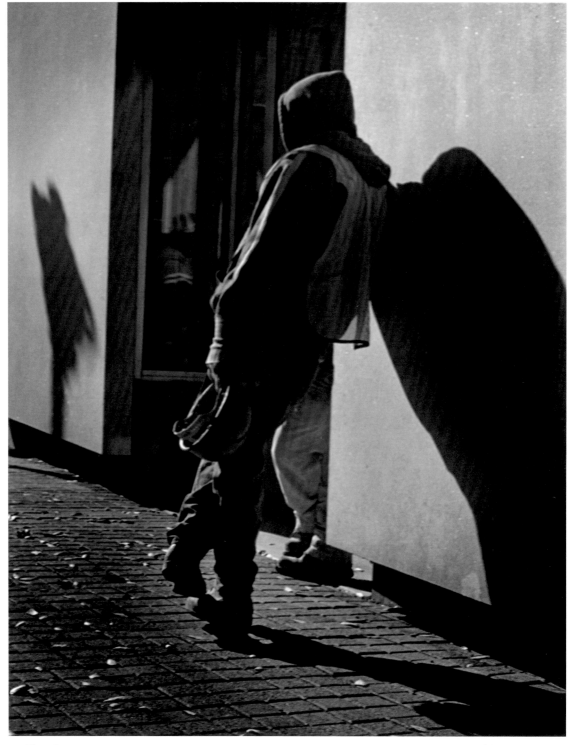

Time Out

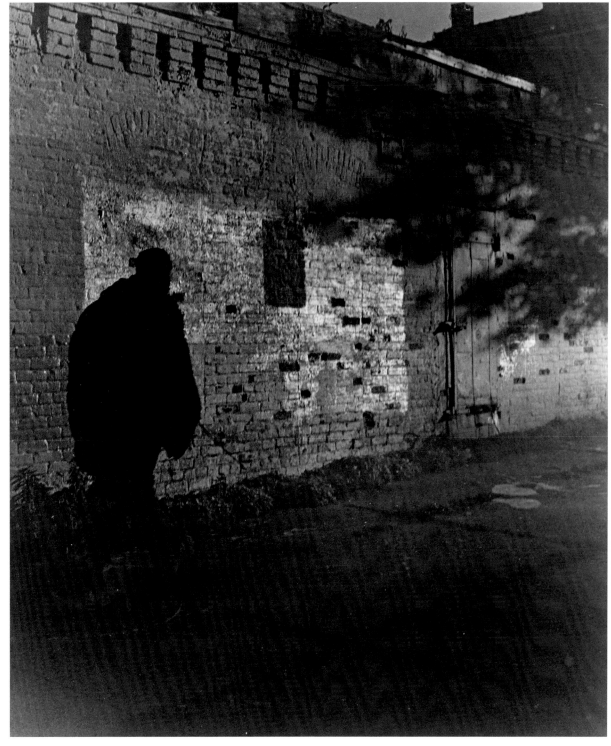

Gold Street Druid Heights, 2006

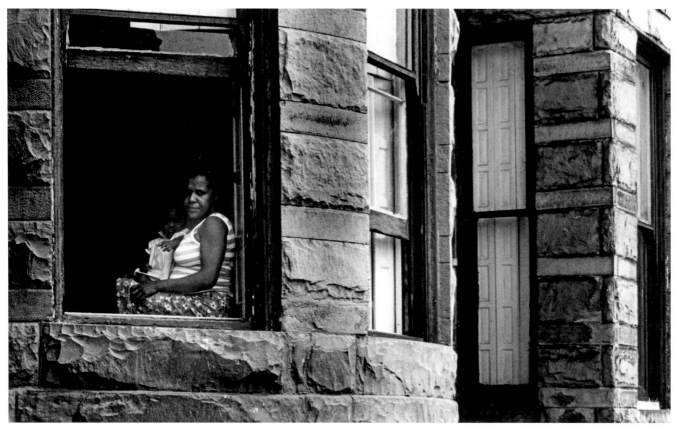

Untitled Park Avenue, Reservoir Hill, 1977

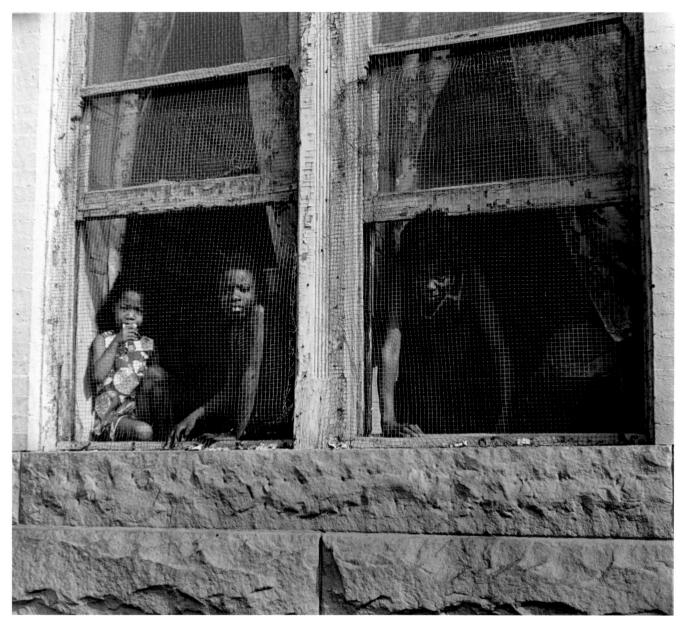

Safe Reservoir Hill, 1977

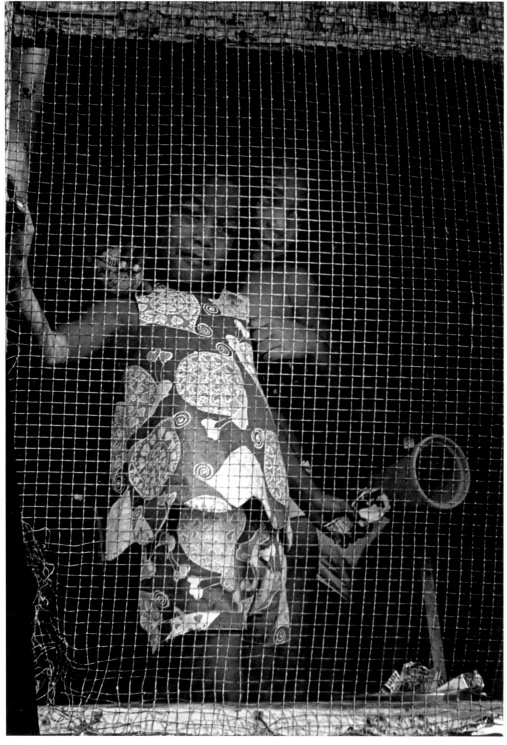

Siblings Reservoir Hill, 1977

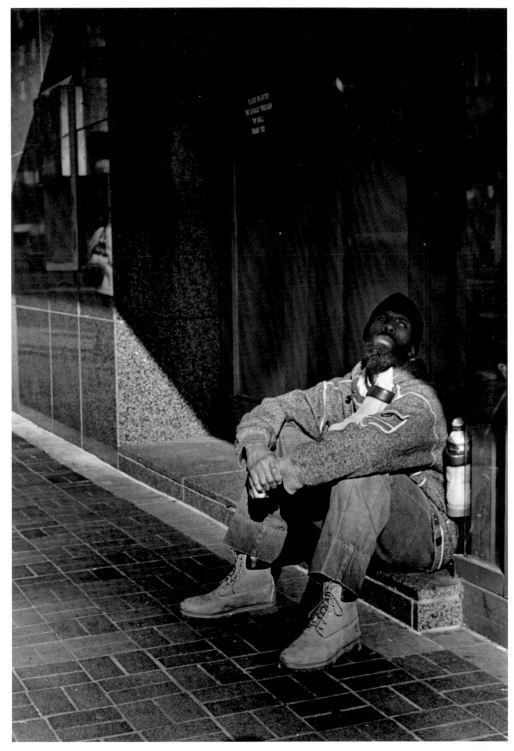

Bus Waiting

South Calvert Street, 2007

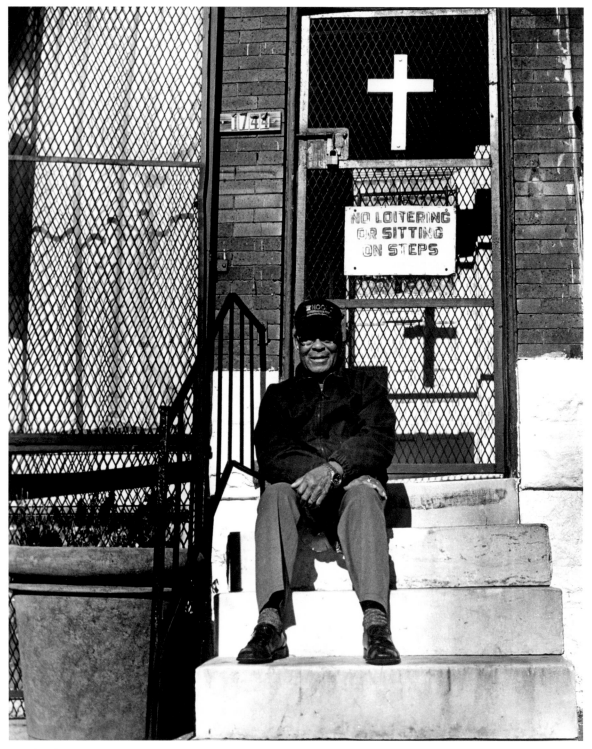

Church

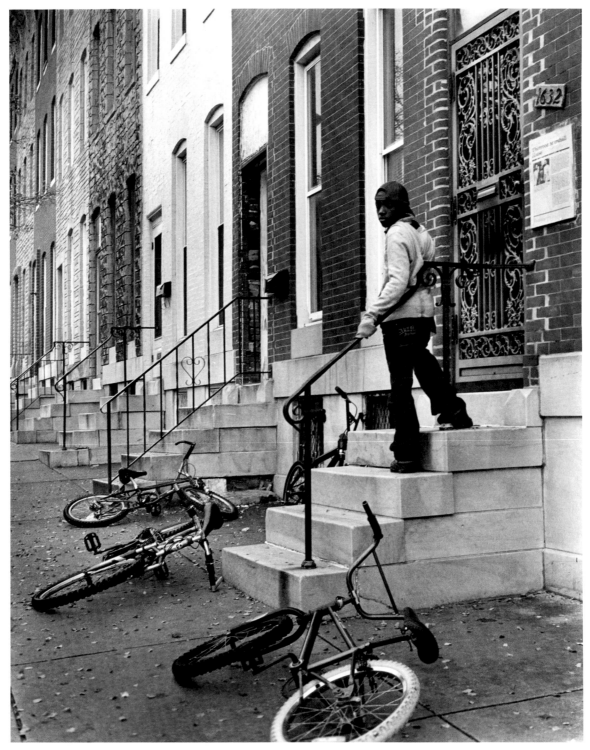

Are These Abandoned 1632 Division Street, Home of US Supreme Court Justice Thurgood Marshall, 2009

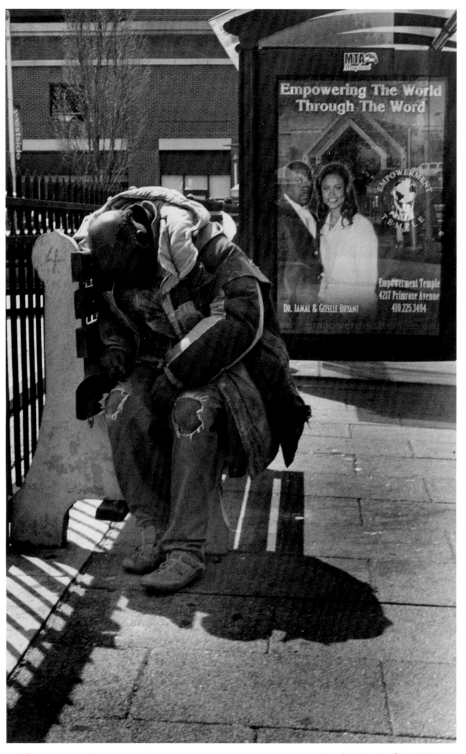

Empowerment Lexington Market, 2007

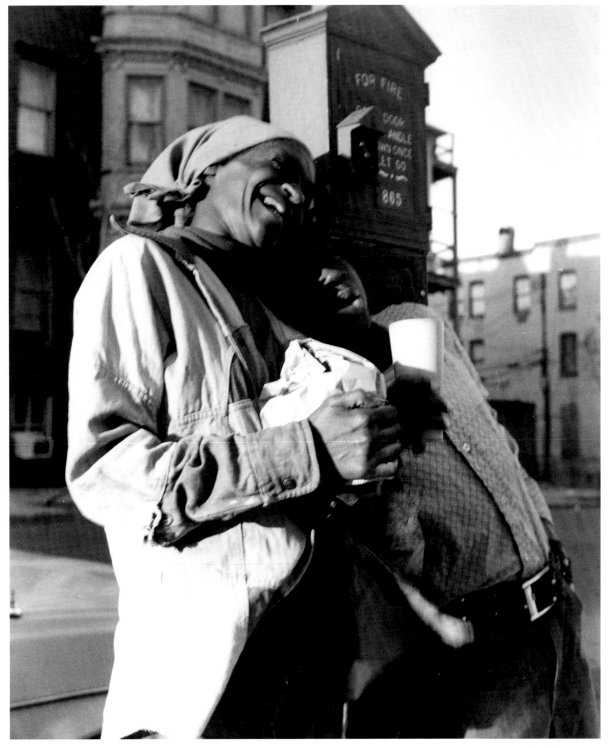

Gloria and Johnny Reservoir Hill, 1978

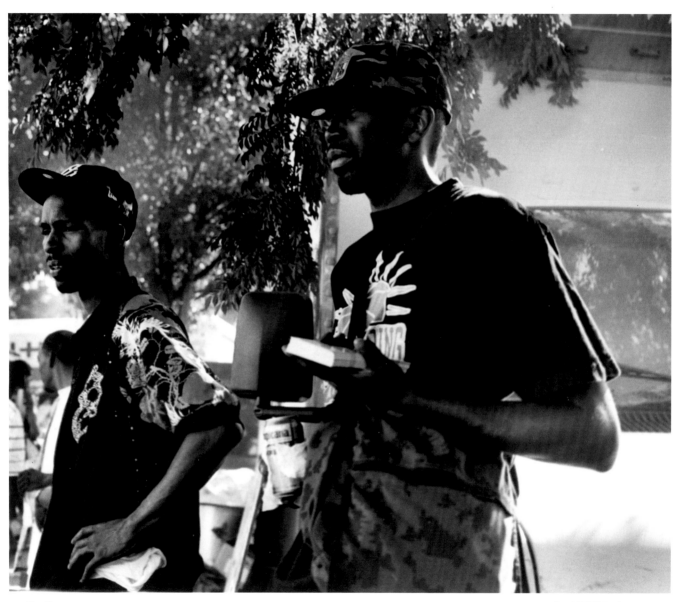

Brothers

Druid Hill Park, 2007

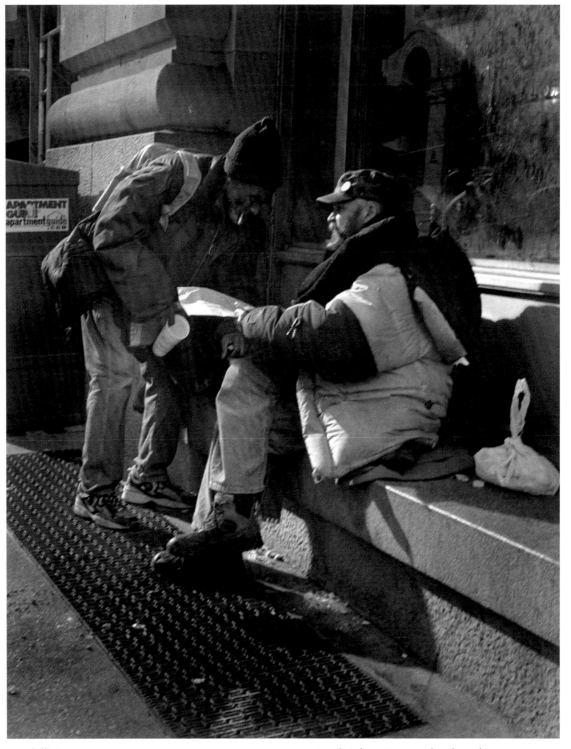

Chillin' South Calvert Street and Redwood Street, 2007

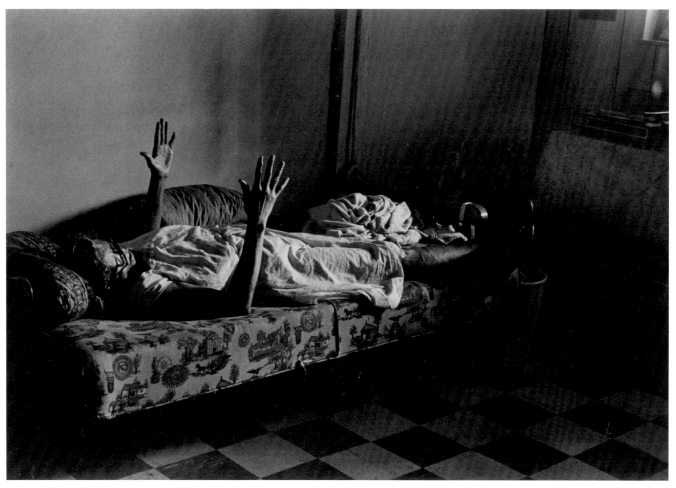

Inspiration

Ruskin Avenue, 1973

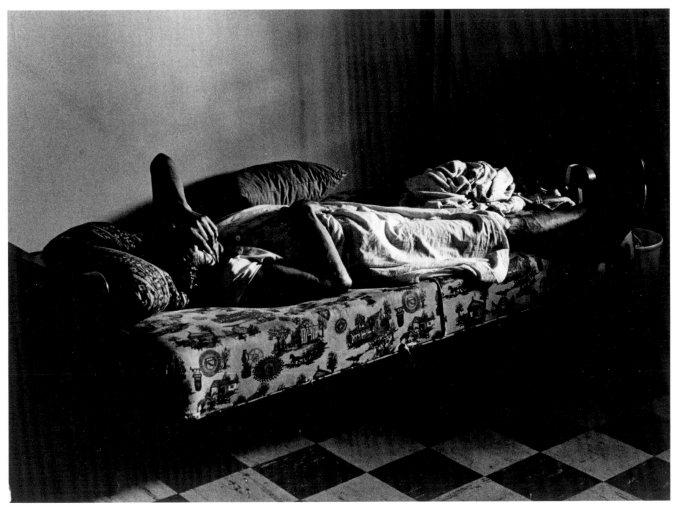

Slumber Ruskin Avenue, 1973

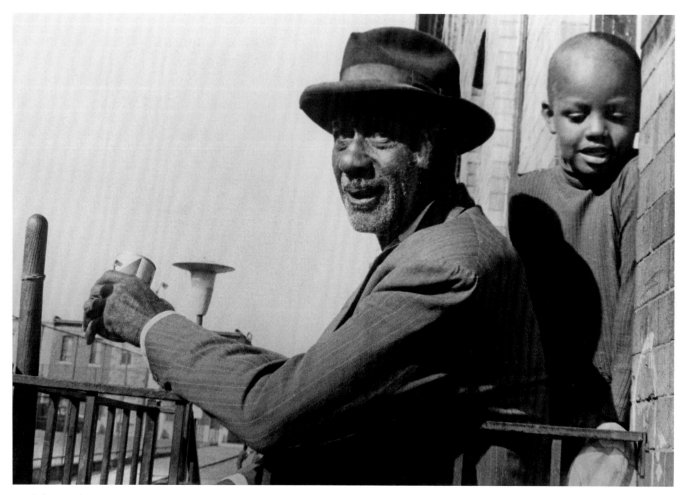

Rejuvenation

East Baltimore, 1975

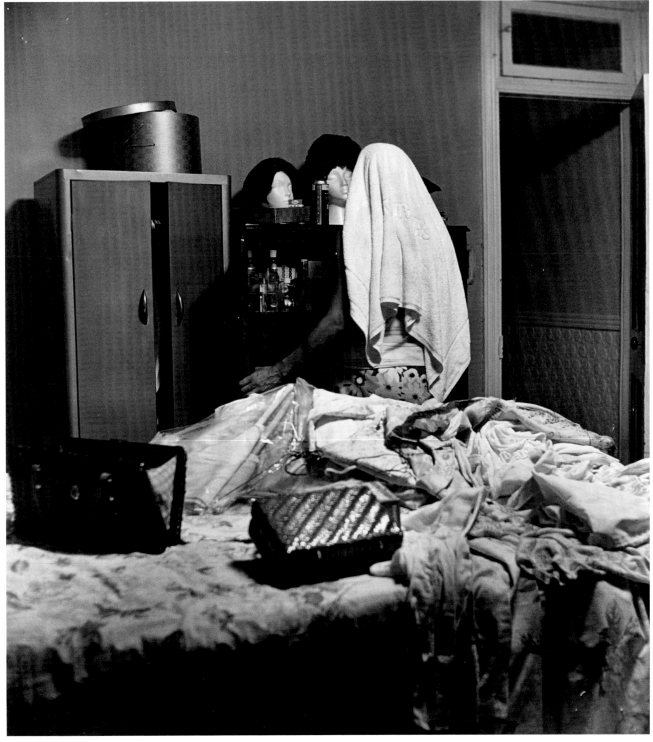

Billie

Ruskin Avenue, 1973

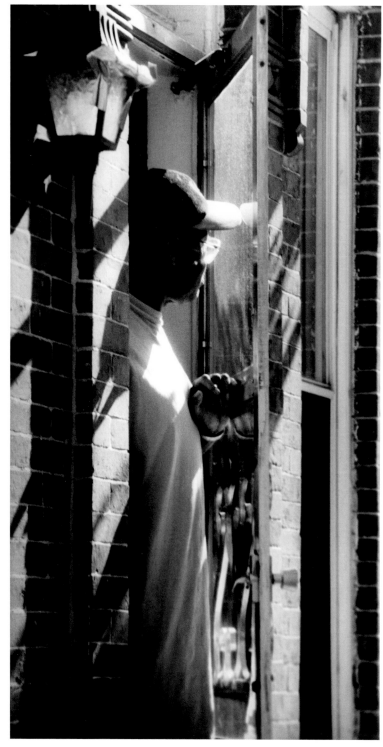

Division West North Avenue, 2008

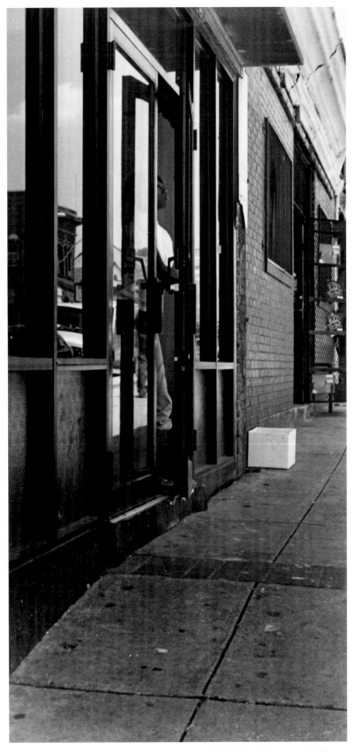

Dreams West North Avenue, 2008

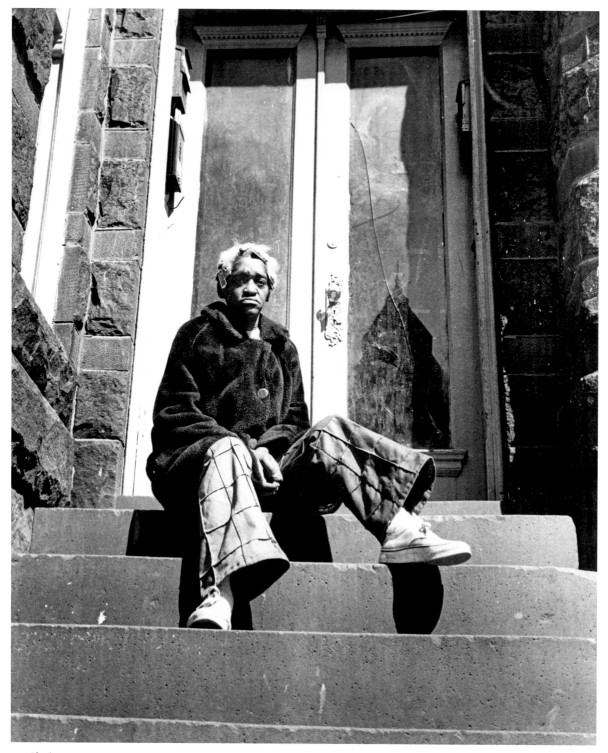

Gloria

Reservoir Hill, 1978

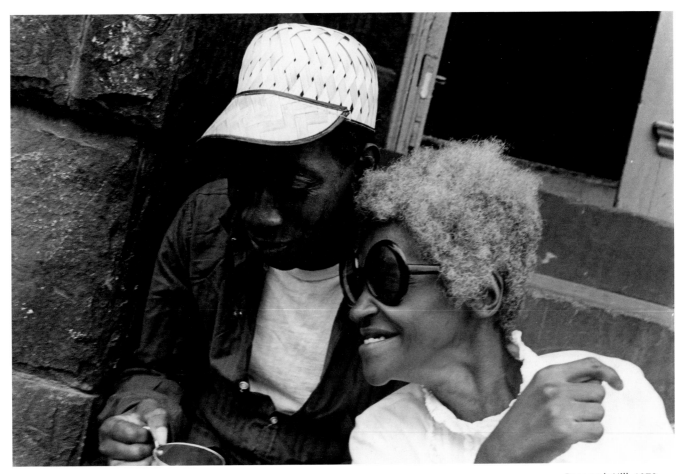

Hillions

Reservoir Hill, 1978

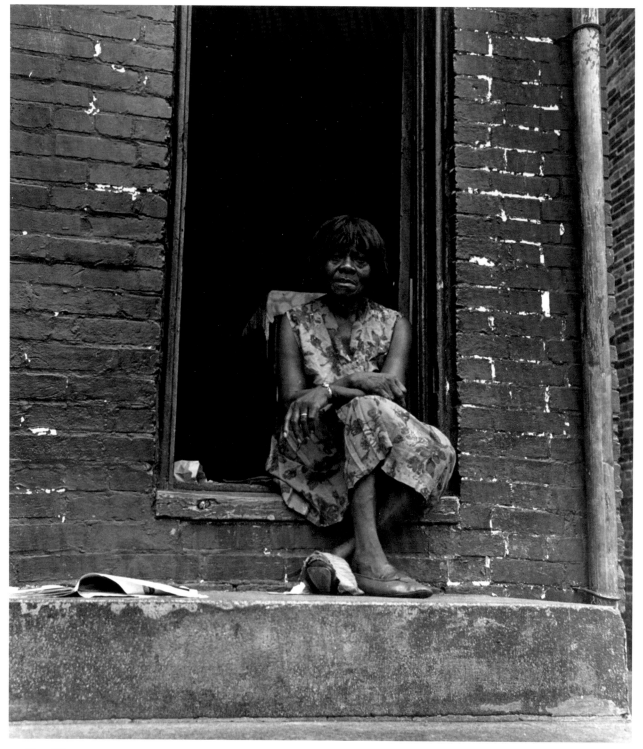

Step Sitter

Near Pennsylvania Avenue, 1972

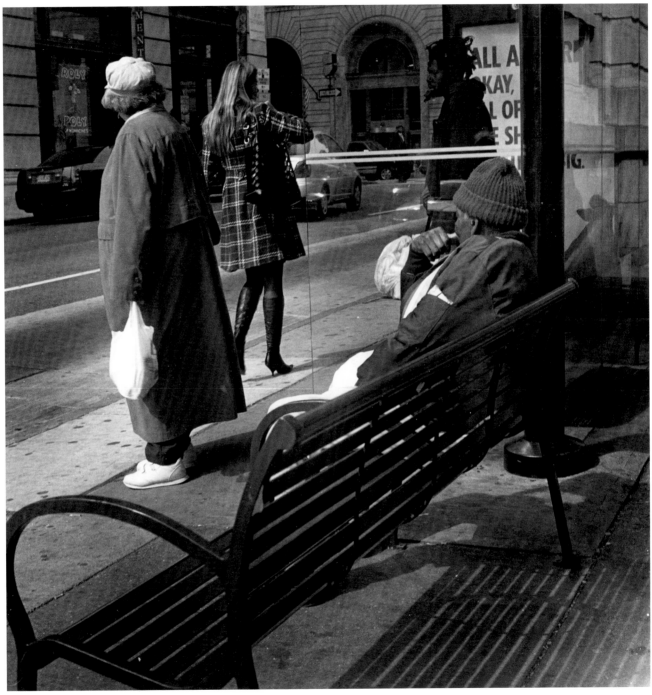

Leggy Lovely

East Fayette Street, 2009

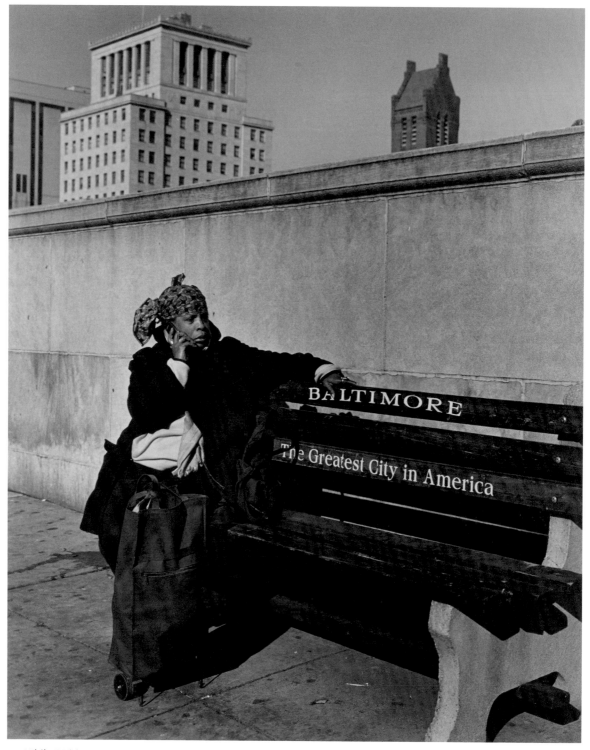

While Waiting

East Fayette Street, 2008

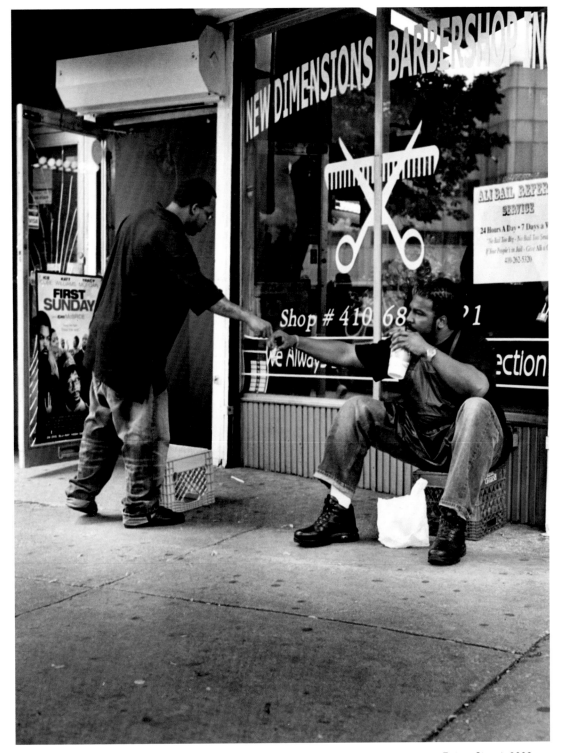

Knuckle Greeting

Eutaw Street, 2008

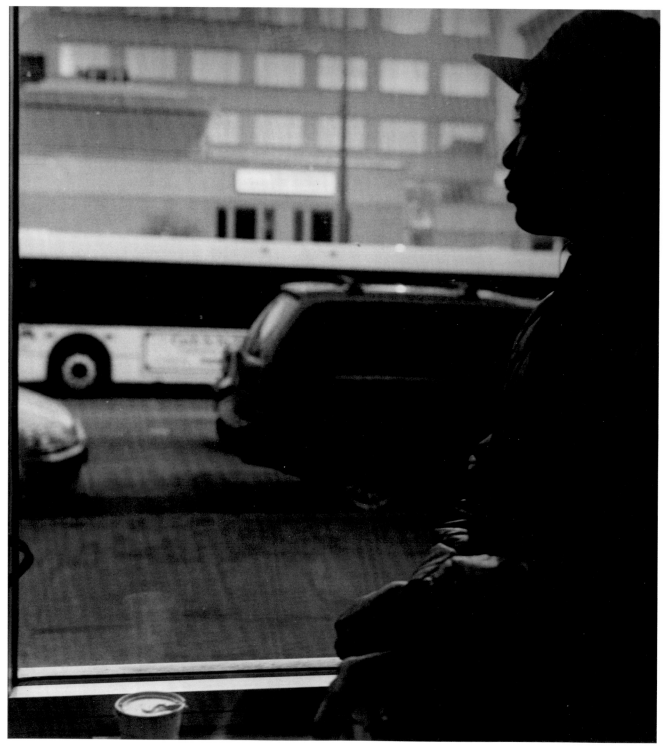

Day Dreaming

Lexington Market East, 2006

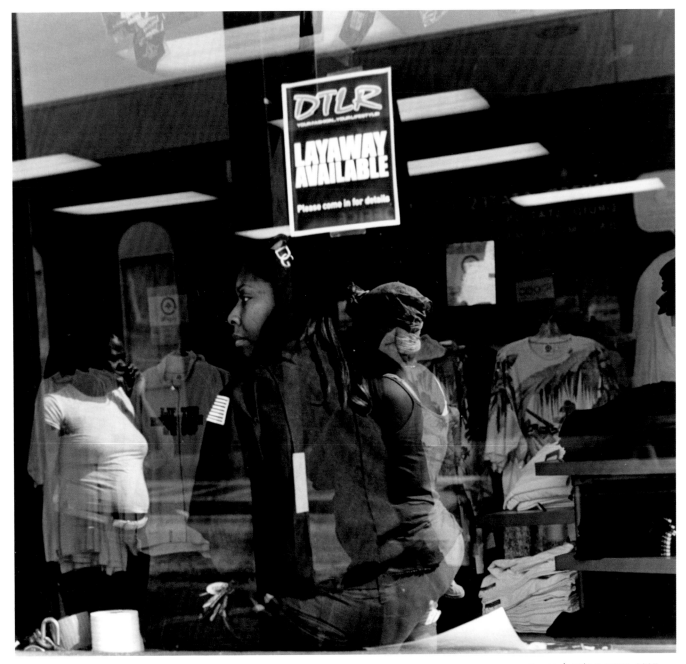

From the Window

Pennsylvania Avenue, 2007

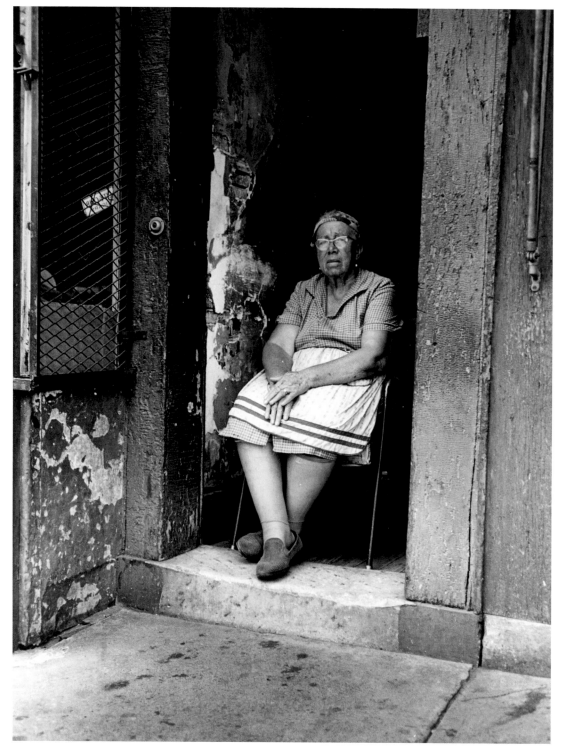

Condition

Pennsylvania Avenue, 1972

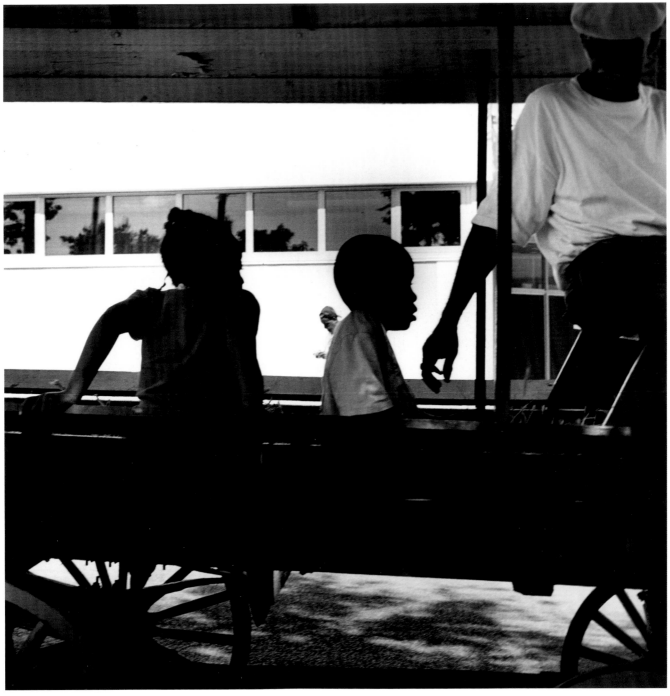

In Transit

Pennsylvania Avenue, 2007

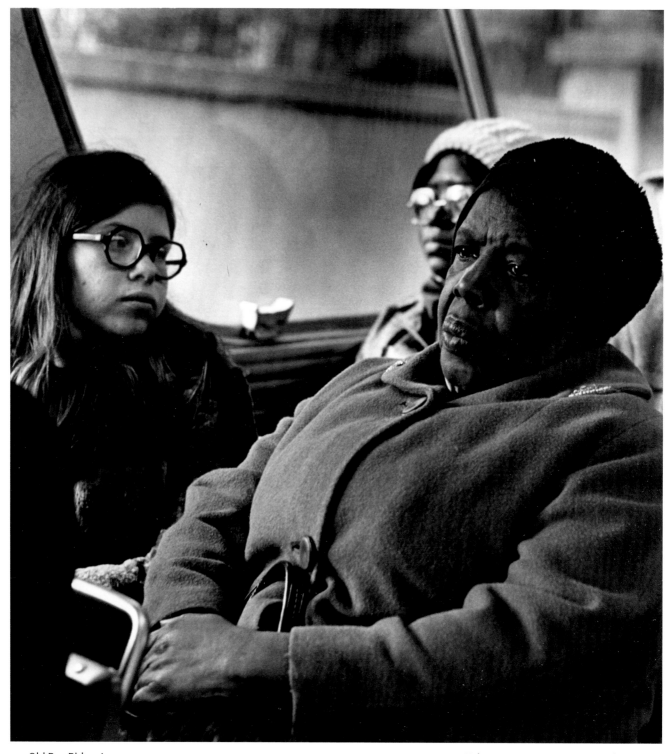

Old Bus Riders I

Fulton Avenue Bus Turnaround, 1973

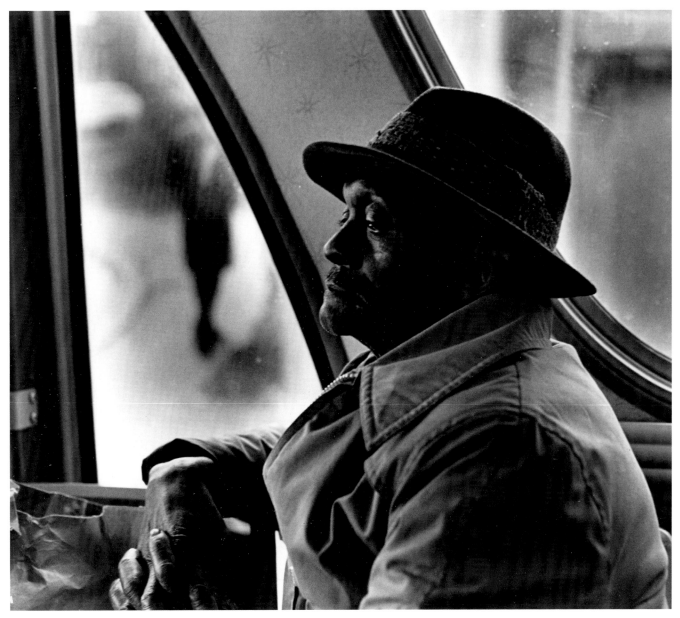

Old Bus Riders II Fulton Avenue Bus Turnaround, 1973

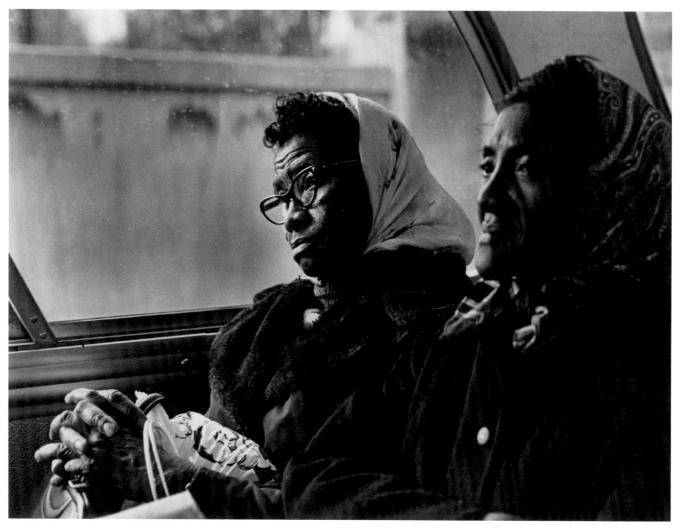

Old Bus Riders III

Fulton Avenue Bus Turnaround, 1973

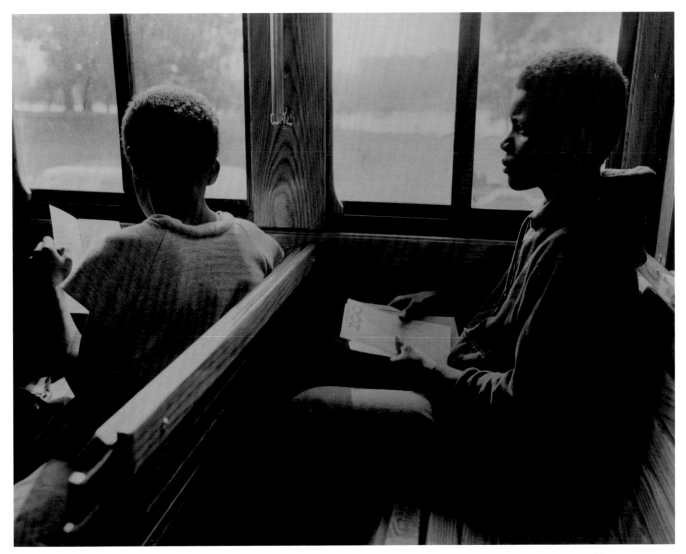

Scenic Trolley Ride

Downtown Baltimore, 1985

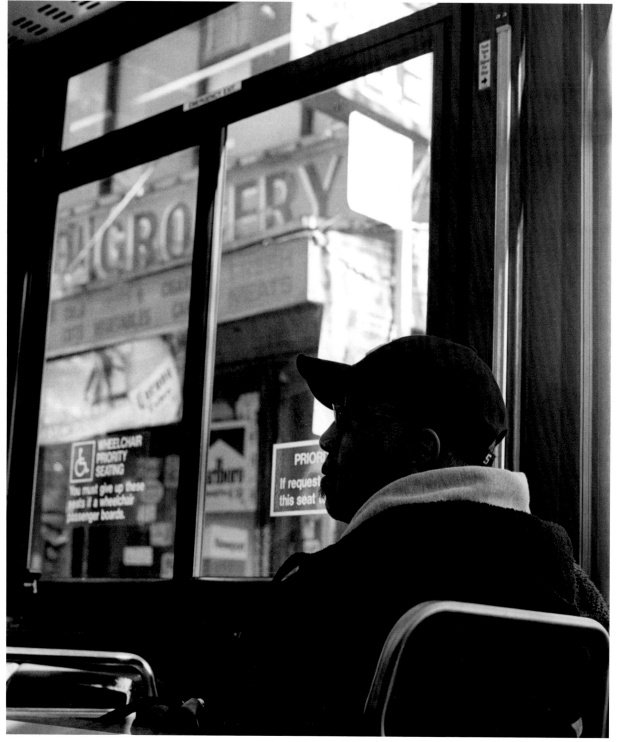

Bus Rider Harlem, New York, 2005

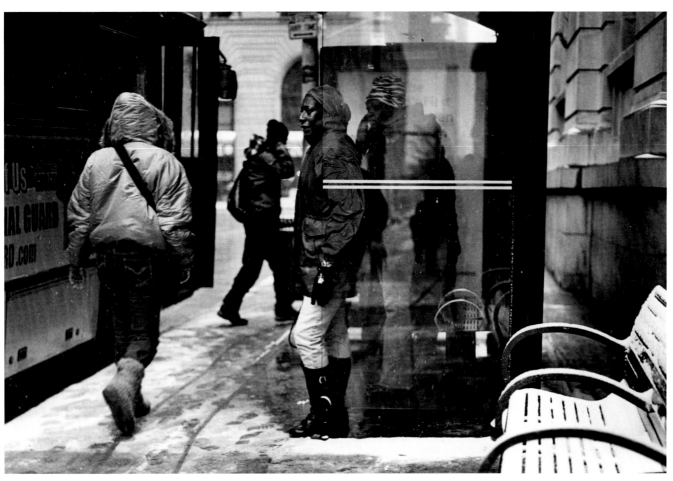

Still Scene

East Fayette Street, 2009

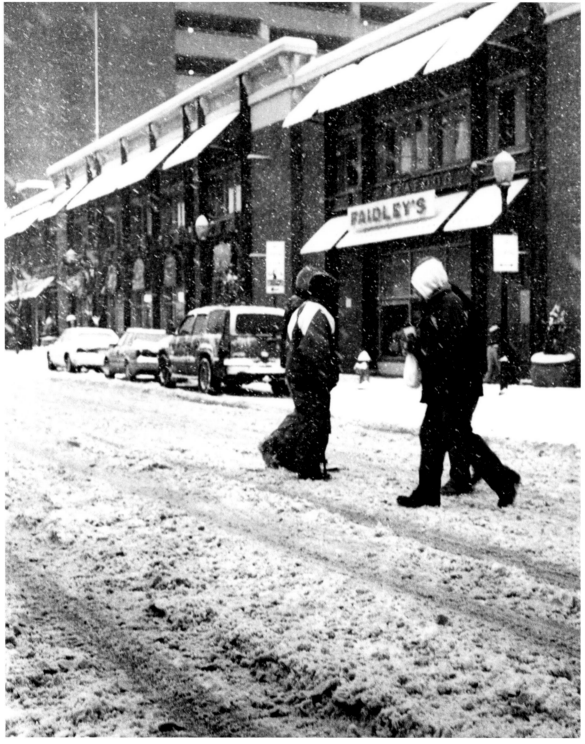

Winter Day Lexington Market, 2009

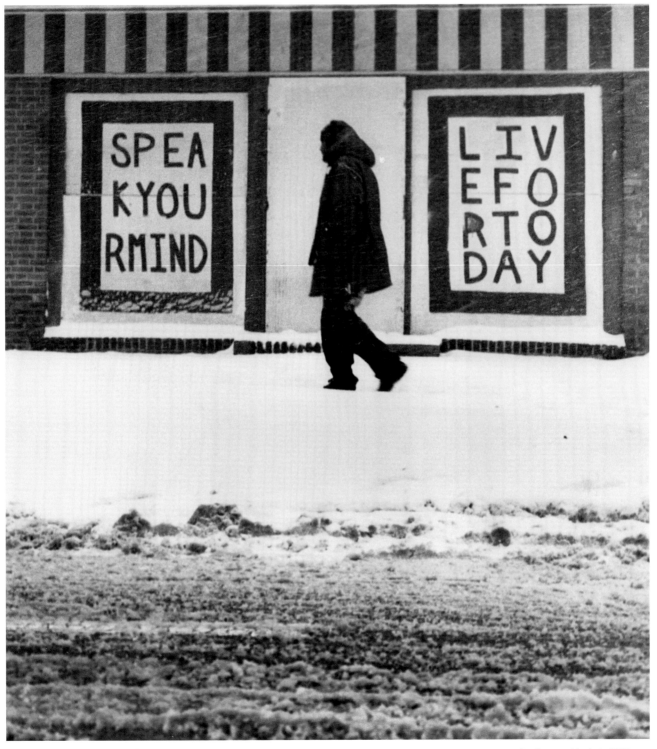

Speak Your Mind / Live for Today Lexington Market, 2009

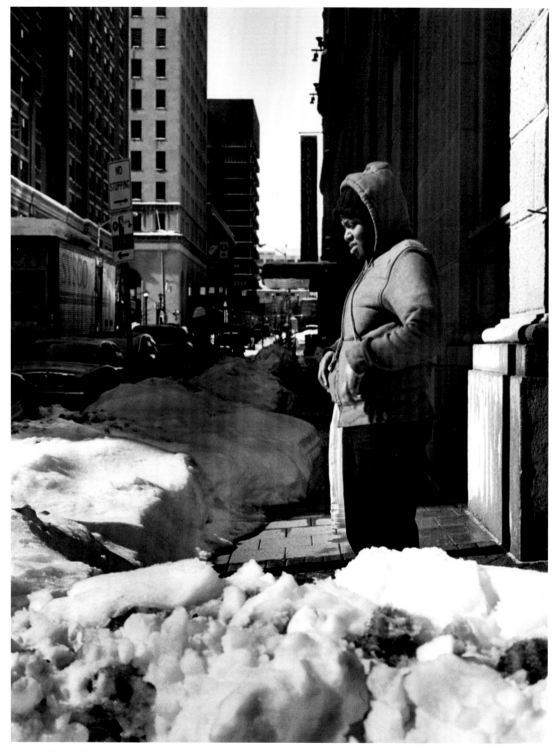

Pondering Options

Downtown Baltimore, 2010

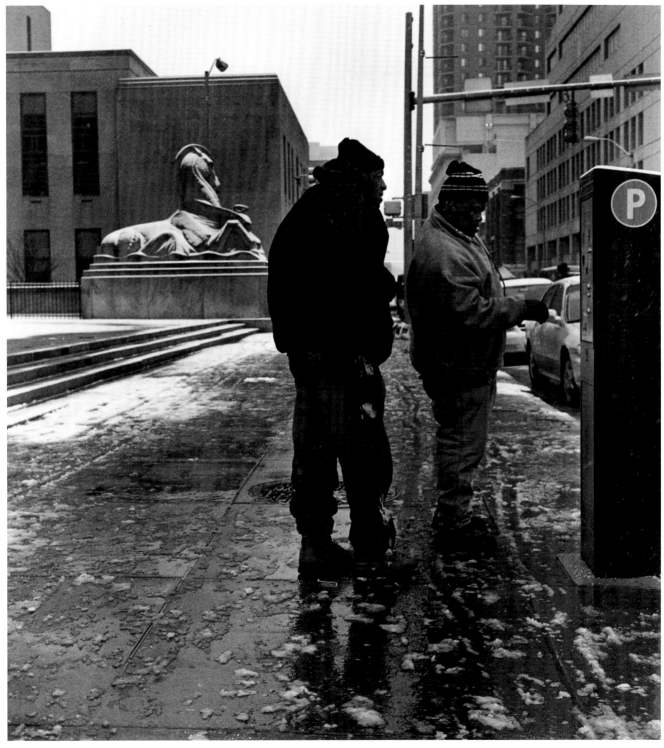

Pay to Stay

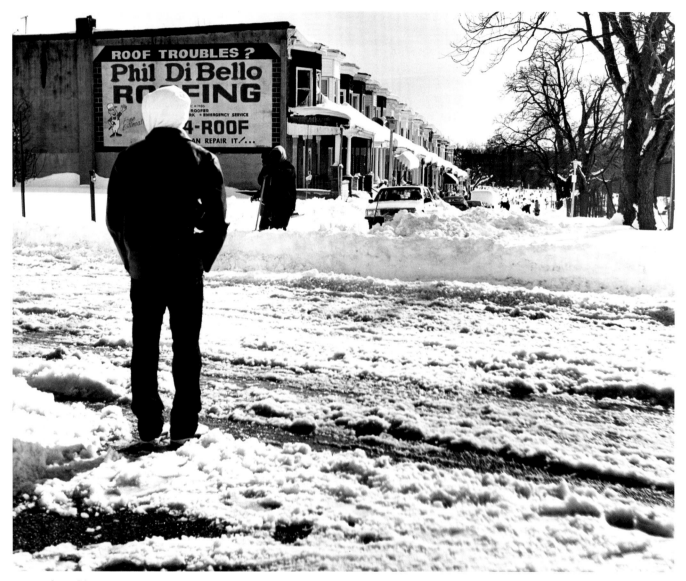

Roof Troubles

Edmondson Avenue, 2010

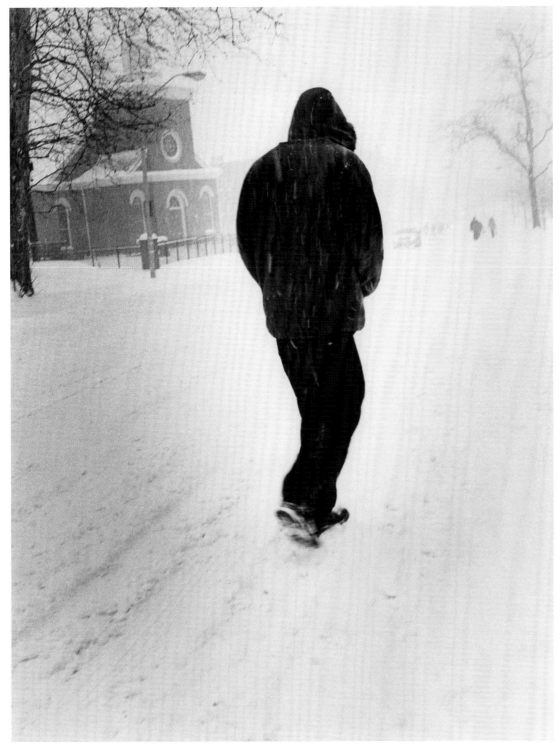

At Walbrook Junction West Baltimore, 2003

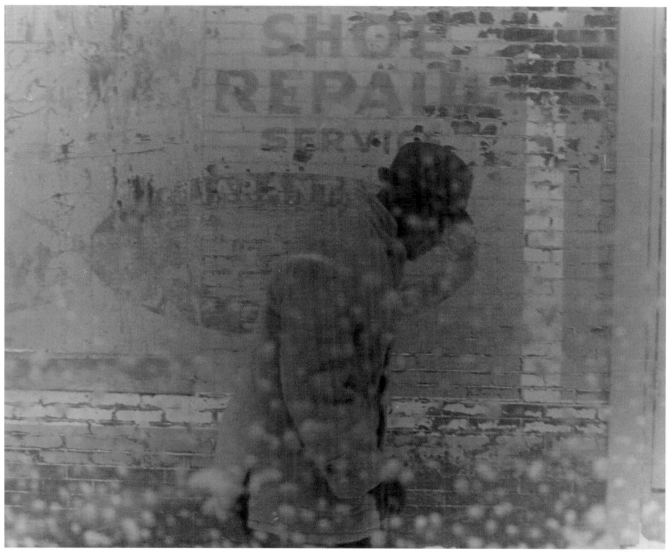

Movin' On

North Fulton Avenue, 1975

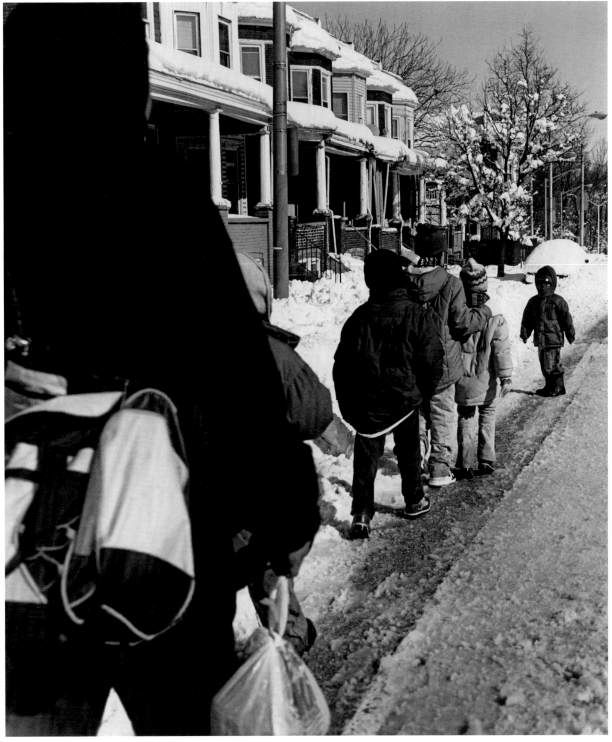

Single File Edmondson Avenue, 2010

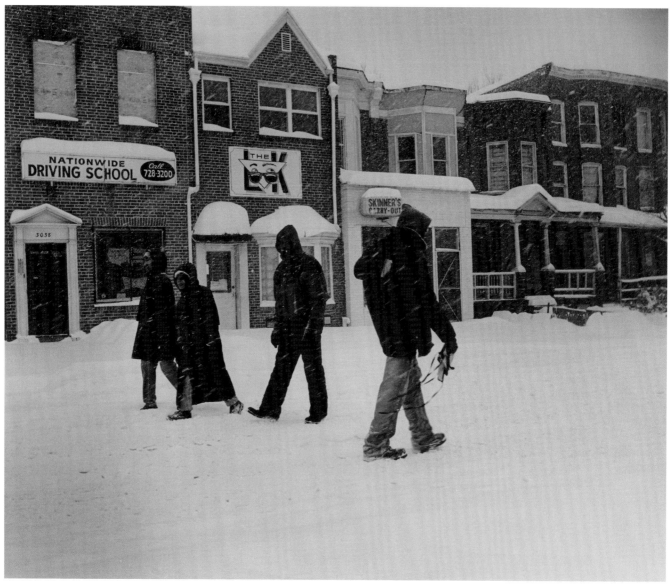

En Route

West North Avenue, 2003

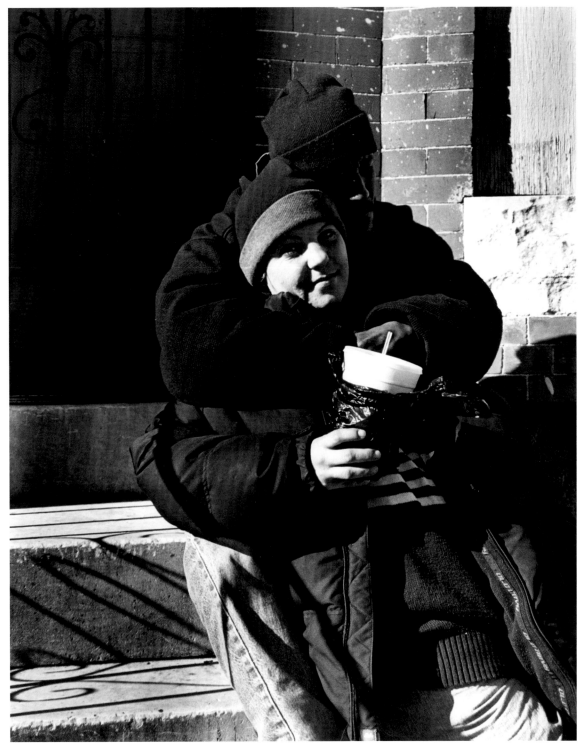

Love Hug Love West North Avenue, 2008

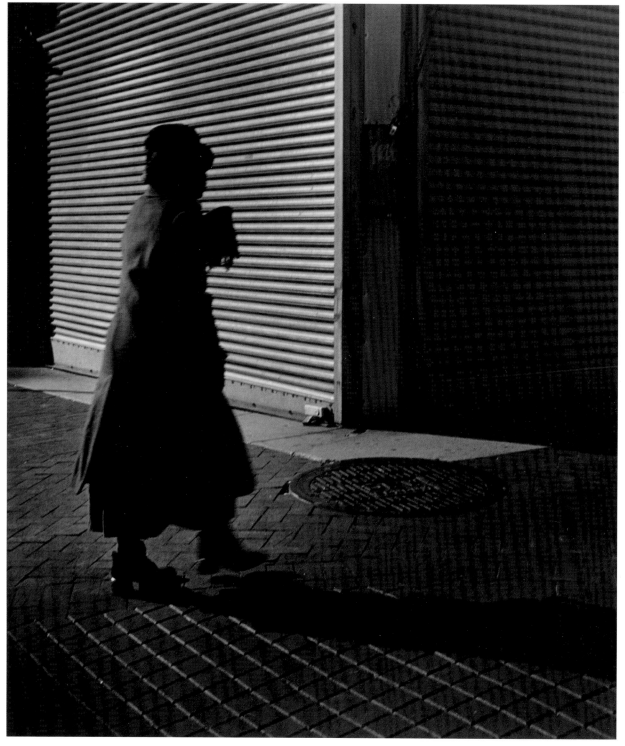

Steppin'

Park Avenue and Lexington Street, 2007

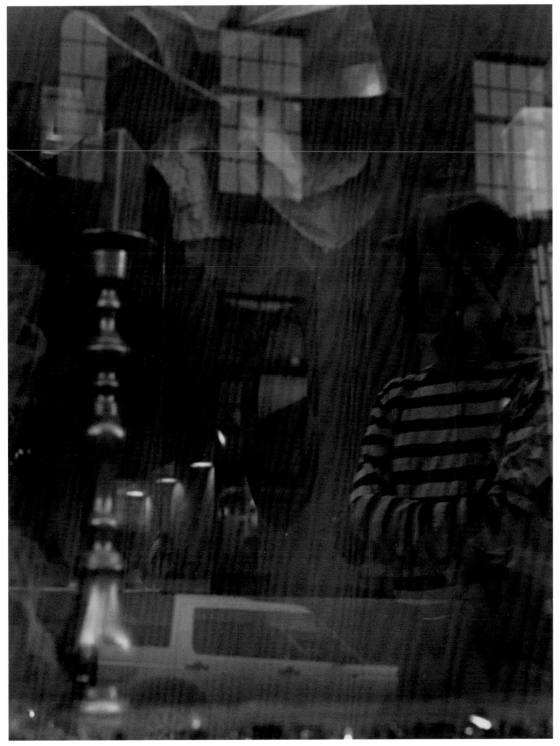

Reflecting Downtown Baltimore, 2007

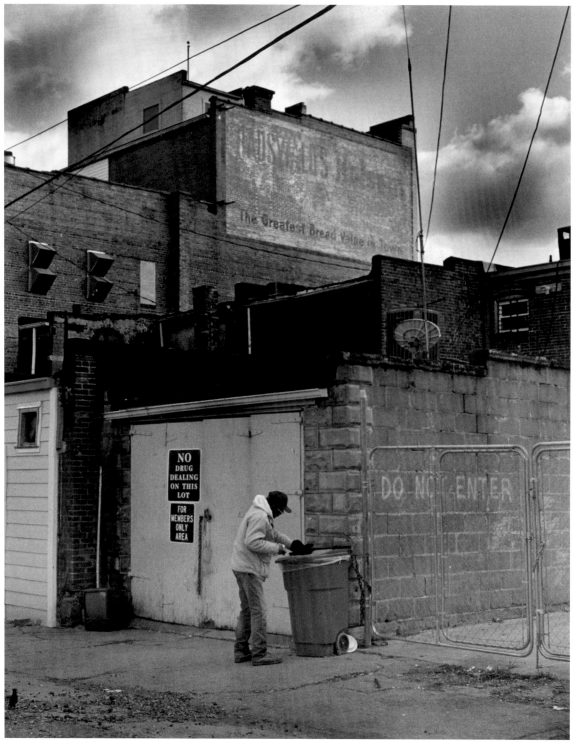

Members Only

Poplar Grove Street, 2007

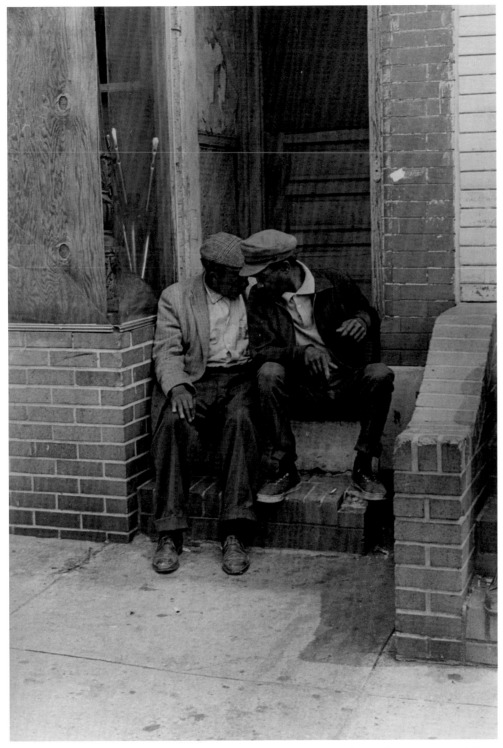

Step Conference Pennsylvania Avenue, 1972

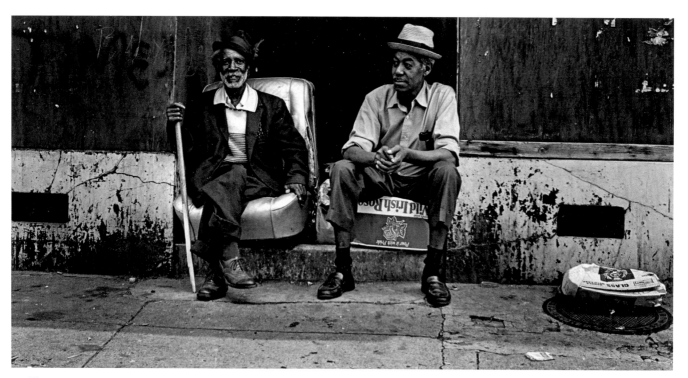

Time

Pennsylvania Avenue, 1972

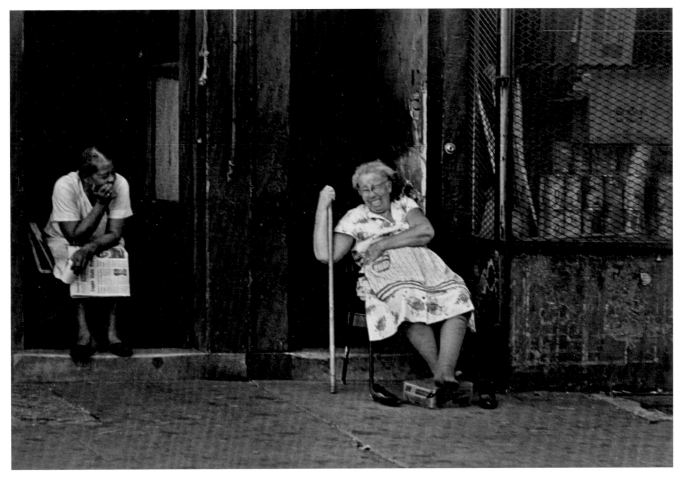

Catchin' a Breeze

Pennsylvania Avenue, 1972

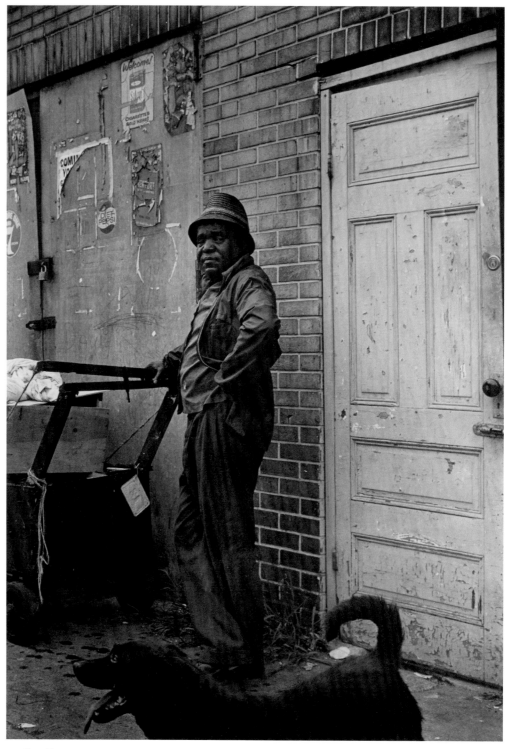

Rag Man

East Baltimore, 1972

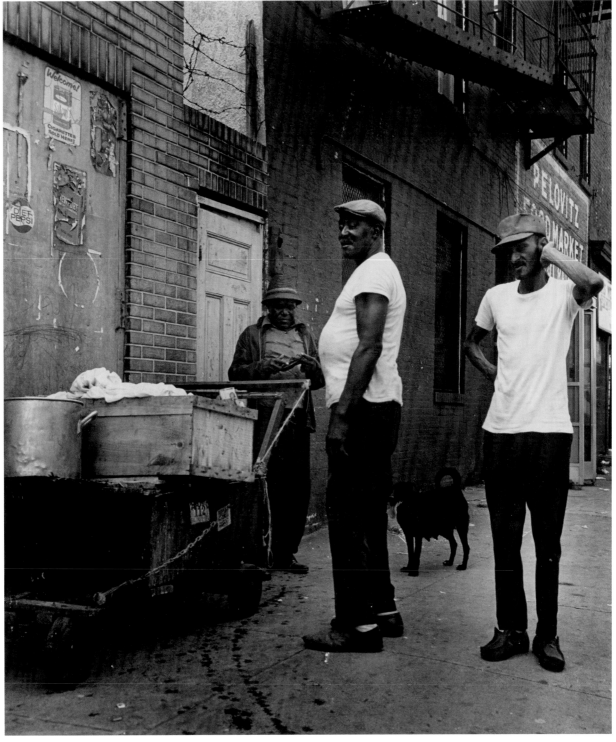

Rag Men

East Baltimore, 1972

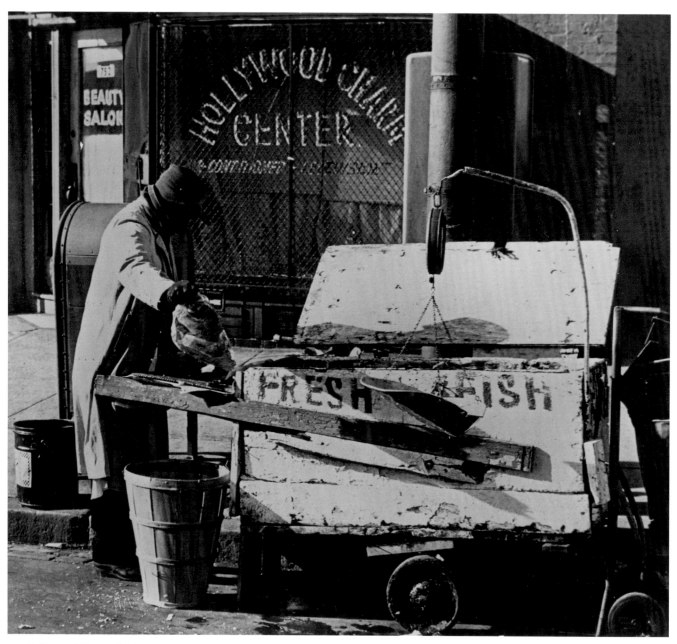

Hollywood Charm Center

East Baltimore, 1970

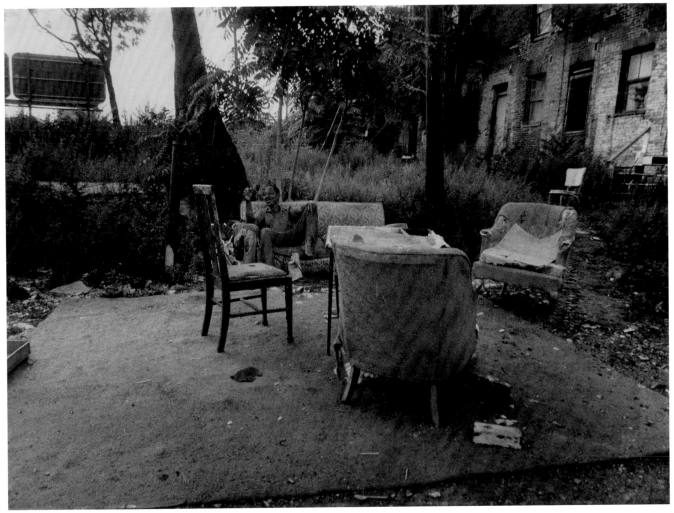

Relaxin'

Highway to nowhere, 1971

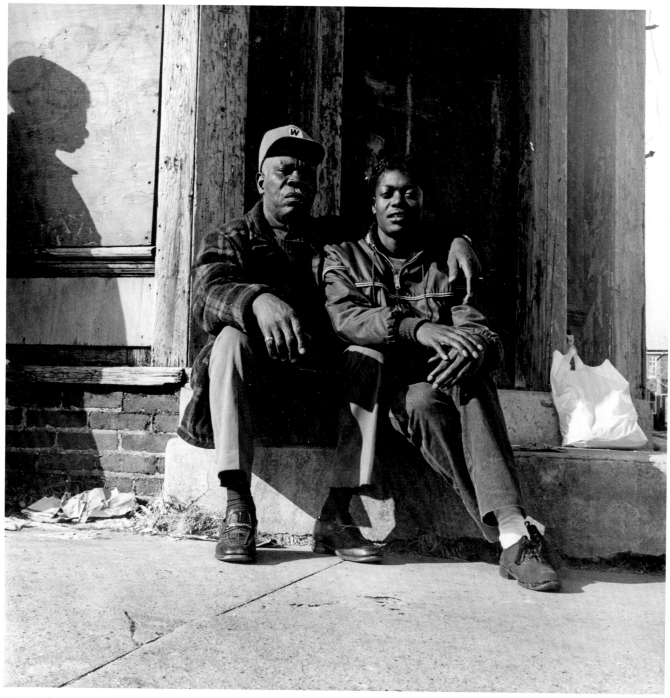

Together

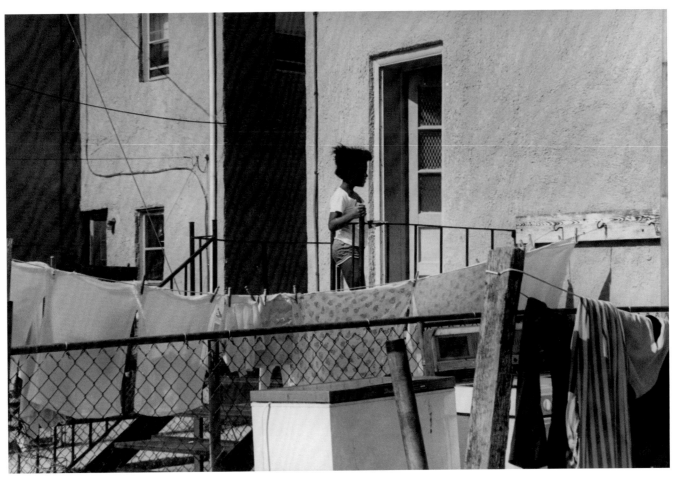

Saturday Wash

Greenmount Avenue, 1980

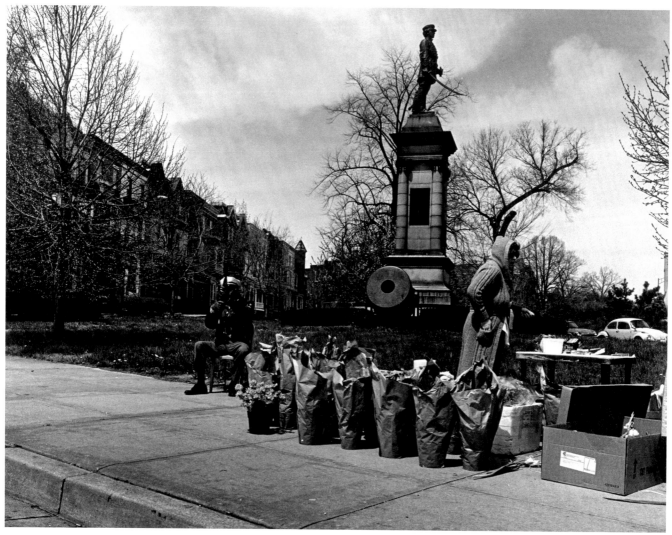

Florist

West North Avenue at Mount Royal Terrace, 1984

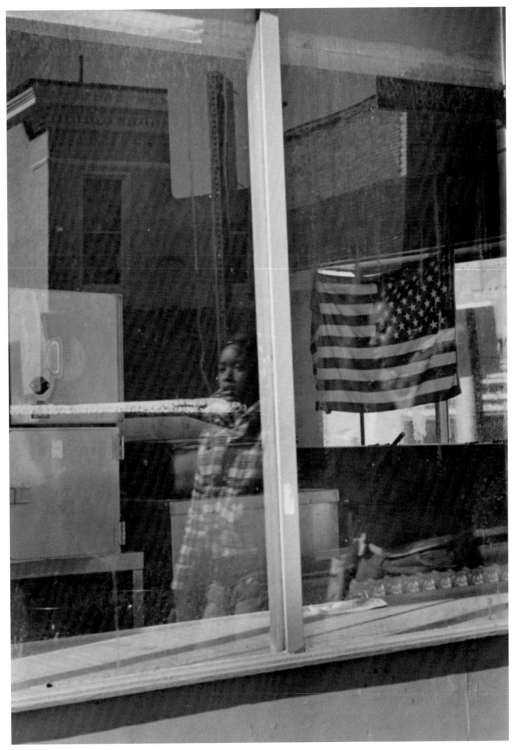

Dream of Liberty Greenmount Avenue, 2007

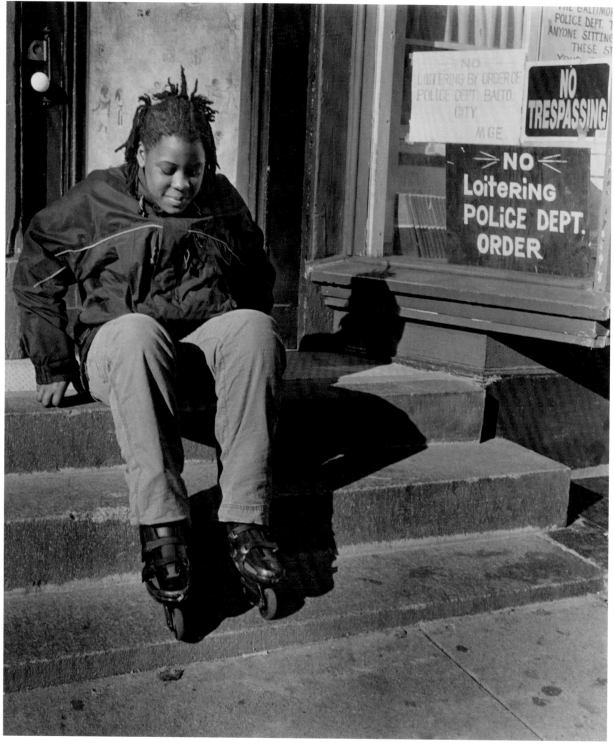

Rest Stop

Park Avenue, 2007

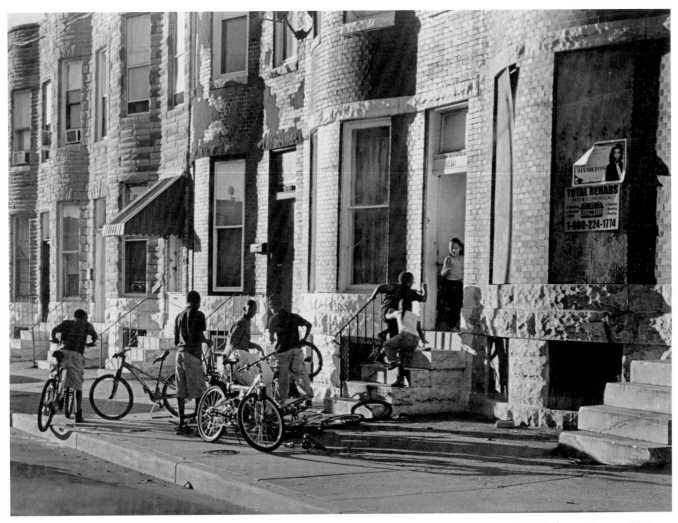

The Gathering West Lafayette Avenue, 2012

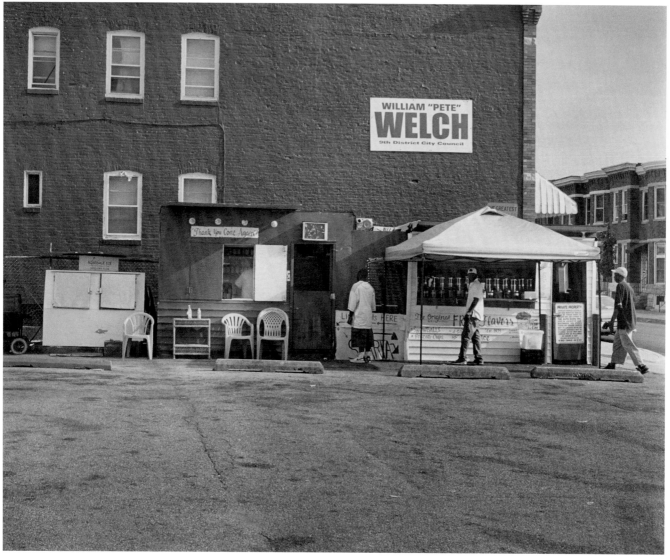

Pop Stand

West Lafayette Avenue, 2012

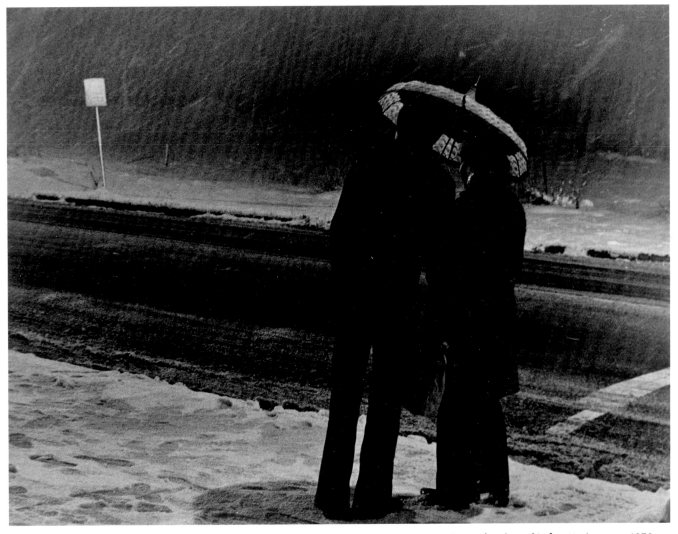

Bus Stop

Pennsylvania and Lafayette Avenues, 1976

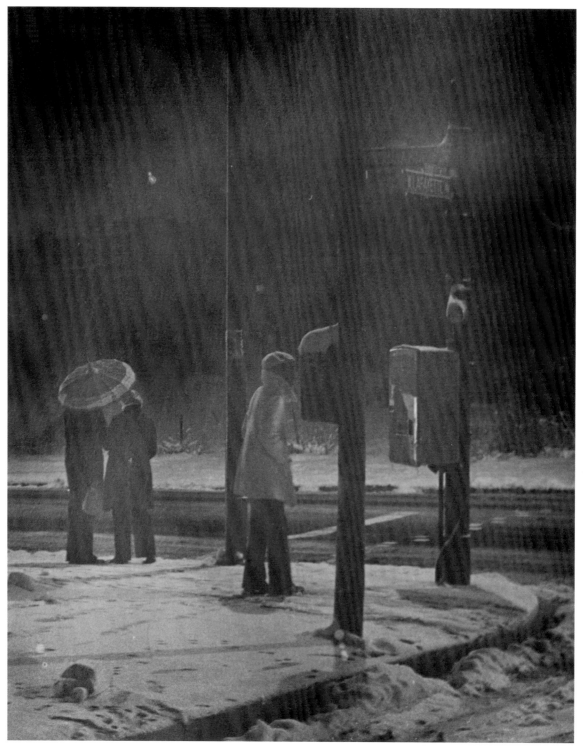

Snow Storm

Pennsylvania and Lafayette Avenues, 1976

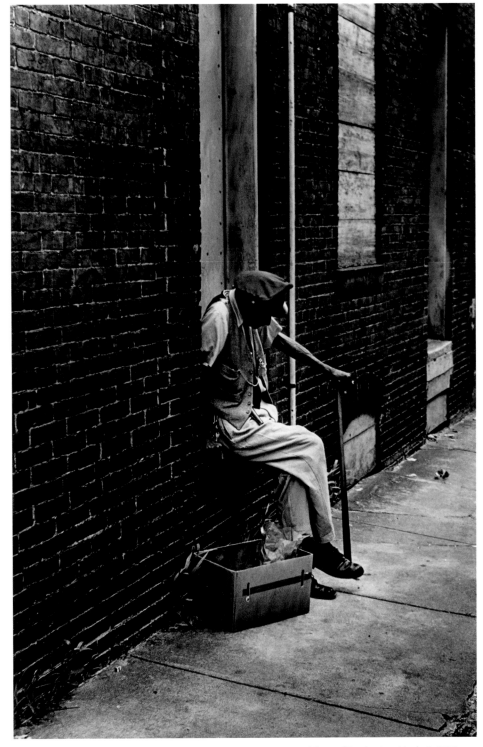

Tex West of Lexington Market, 1971

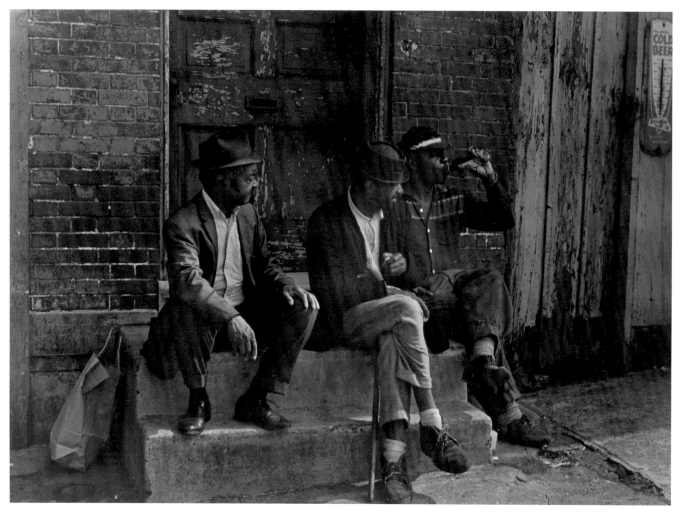

My Turn

Pennsylvania Avenue, 1971

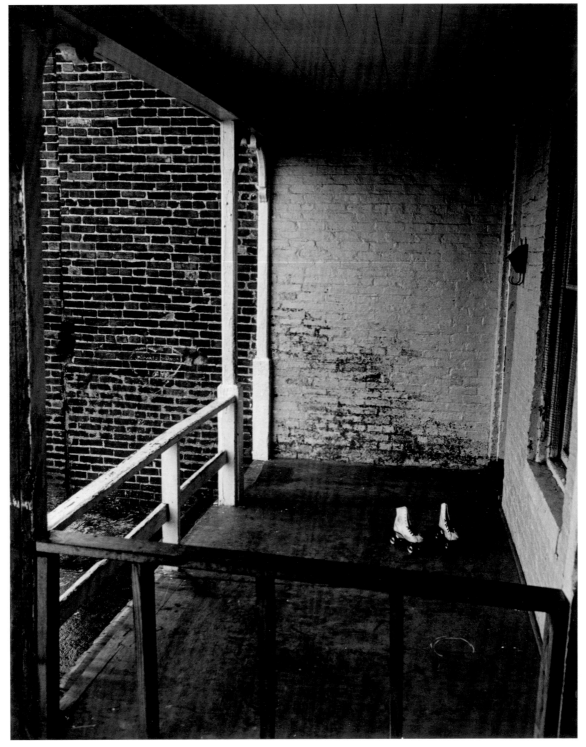

Skates Resting

Monroe Street, 1984

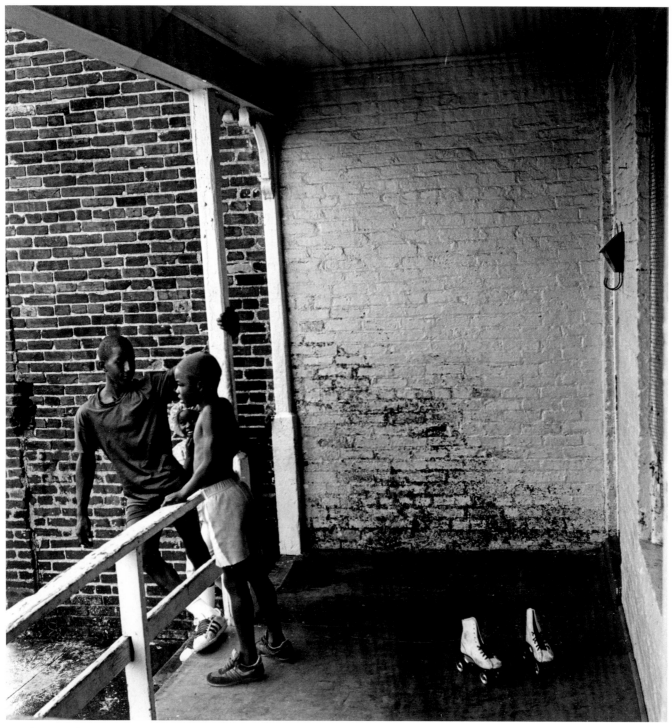

Skate Break

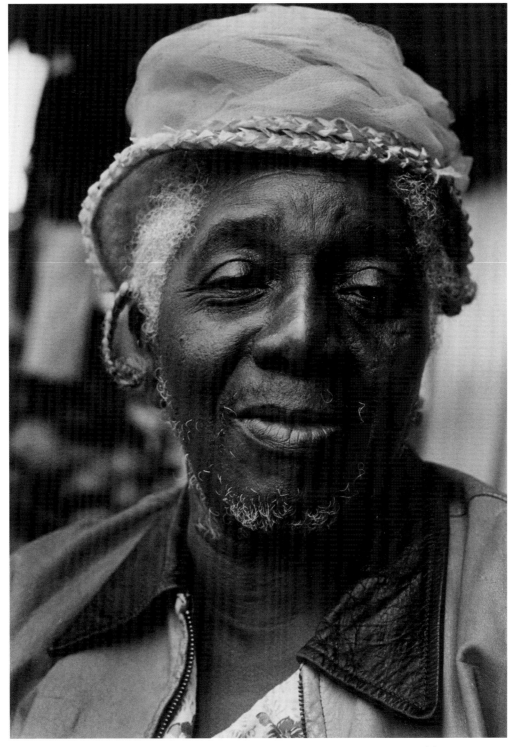

Lady West Baltimore, 1974

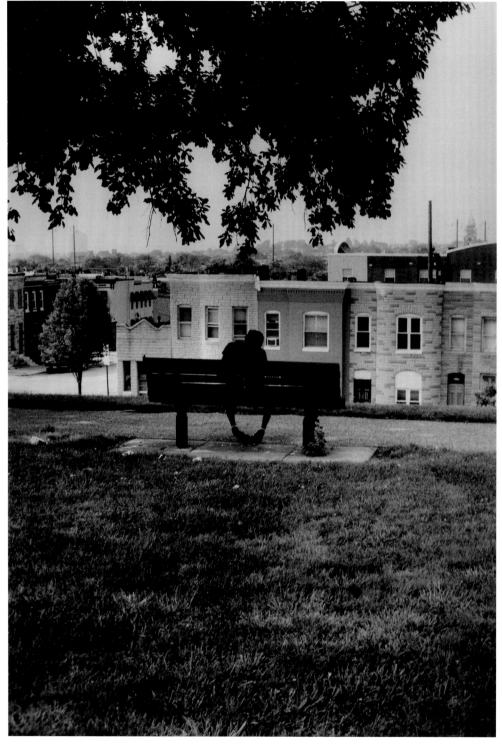

Patterson Park

East Baltimore, 2005

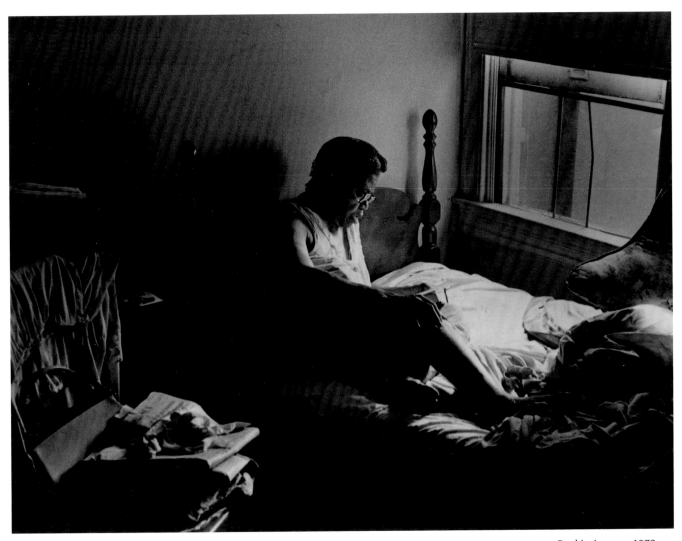

Granny and Her Bible Ruskin Avenue, 1973

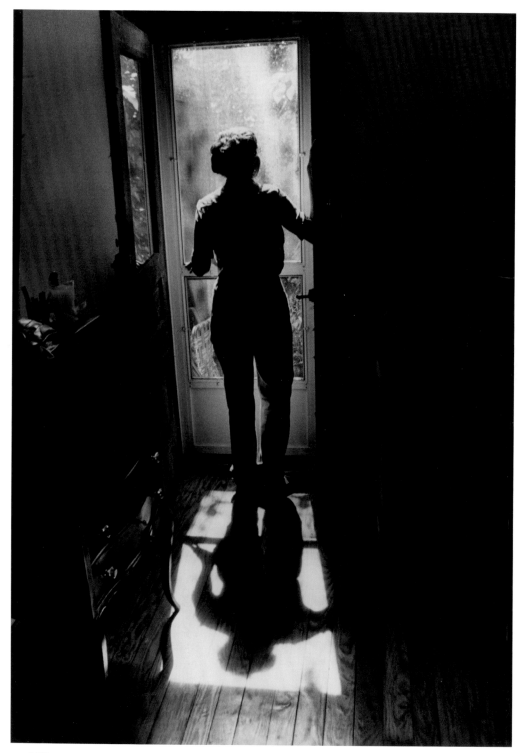

Billie Sun Gazing

Linden Avenue, 1978

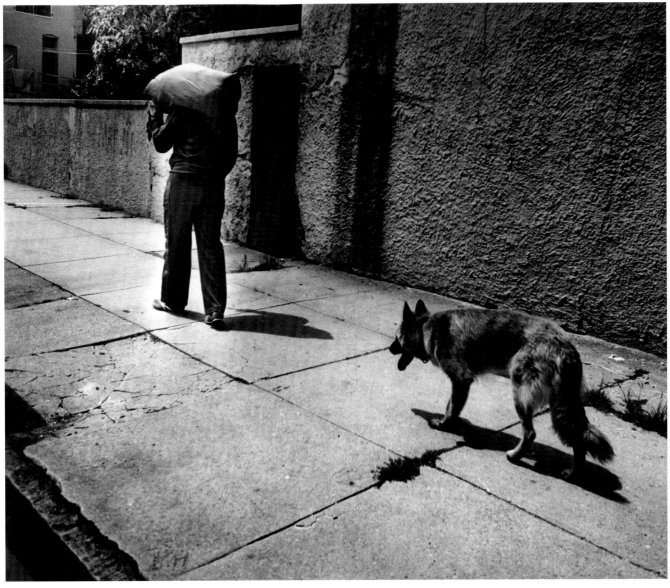

Mirror Image

Ducatel Street, Reservoir Hill, 1978

A Curator's View

Gabrielle Dean, PhD

William Kurrelmeyer Curator of Rare Books & Manuscripts
The Sheridan Libraries, Johns Hopkins University

John Clark Mayden takes pictures of people going about their everyday lives, in places that are familiar to them. Although he has photographed people in Virginia, Florida, New York, and elsewhere, the people on the other side of his lens mostly live here in his hometown. It is as a lifelong Baltimorean that he sees them, and his knowledge of this city's history infiltrates his pictures—like the screens on the rowhouse windows through which he occasionally seeks his fellow citizens.

The Baltimore history that permeates these photographs includes an antebellum period during which a large free Black population began the determined work of building, over several generations, essential and durable institutions: churches, schools, universities, political clubs, banks, hospitals, newspapers, and fraternal societies—the Baltimore where Frederick Douglass spent formative years as a boy and young man before escaping from slavery. It includes a cultural flowering amid Jim Crow restrictions, which created the arts and nightlife mecca of Pennsylvania Avenue—the Baltimore where Billie Holiday grew up and learned to sing. It includes the growth of a middle class and an influential Black elite, who continue to shape the city through Black and integrated organizations.

As a civil rights activist and attorney, Mayden moves easily in these latter circles. But, as a photographer, he is drawn to Baltimore's impoverished Black neighborhoods. Although some of his photographs offer shrewd, loving glimpses of people he knows well or has known, most of the people in his pictures, even when they have encountered each other repeatedly, are more or less unknown to him. In this Black Baltimore, in the places that have been abandoned along the path of progress, Mayden assumes the work of an observer. He seems most interested not in connecting personally to his viewers or even to his subjects but, rather, in advancing the connection between viewers and subjects. Mayden's photographs insist that the subject is also a potential viewer and the viewer, even the privileged stranger, can be pulled into the perspective of the subject.

Subjects and viewers intersect through what is most ordinary—daily life—on the ground that they share, literally or figuratively: this city, especially the parts of town white people tend to avoid. Mayden invokes this landscape and its history of being cast aside by acting as a finder and framer of scenes. There are images that hit you hard with their mystery and some that seem poised on the precipice of a tragedy. But most of

these photographs are not explicitly dramatic. Mayden resists too much "aha!" and too much pity. A true picture is what he's after. It entails a conscientious, stubborn effort to show to outsiders the stark reality of neglect in an American city and, simultaneously, to witness with insiders the dignity of their struggles and triumphs. To the people who appear in these photographs, Mayden seems to say, *I see you, and I see where you are, as much as I can.* To the people who behold these photographs, he says, *Now do you see who and what I see? Look.*

The photographs presented here are, for the most part, drawn from the John Clark Mayden Collection at Johns Hopkins University. They were selected and sequenced by Mayden and his son, Adam, with assistance from me and Jackie O'Regan, curator of Cultural Properties, as co-stewards of the collection. We spent several long and profoundly enjoyable days looking at prints spread out on the largest table we could find, discussing their qualities, absorbing the perceptions they realize. This process revealed to me Mayden's compassionate and disciplined approach to his photographic mission.

Many of these prints are also on view in *City People: Black Baltimore in the Photographs of John Clark Mayden*, an exhibition at the George Peabody Library in Baltimore, which runs October 7, 2019, through March 1, 2020. Assembling *City People*, with co-curator Christina Thomas, Denis Family Graduate Student Curatorial Fellow, has been an honor and a privilege. We would like to thank John and Bronwyn Mayden and their family for placing their trust in us and in Johns Hopkins University, and for allowing us to share these photographs with our city and beyond.

Index of Images by Year